PHOTOGRAPHY AS A FINE ART

CHARLES H. CAFFIN

With an Introduction by Thomas F. Barrow

MORGAN & MORGAN, INC., Publishers

Hastings-on-Hudson, New York 10706

International Standard Book Number 0-87100-019-9
Library of Congress Catalog Card Number 73-167715
First Printing of Facsimile Edition, December, 1971
Printed in the United States of America

The turn of the century brought a revival of the age-old question — Is Photography Art? The participants in this dispute embraced divergent views. Those who doubted the possibilities of photography and its claim to being an art form included a host of critics and writers for the popular journals of the time, among them William B. Dyer, Dr. Charles Miller and P. H. Emerson, the author of *Naturalistic Photography*, published in 1889. On the other side, and in a sense the instigator of much of the controversy, was Alfred Stieglitz, aided by the group surrounding him. Stieglitz was emerging as a powerful force and a controversial figure as a result of his participation as a juror in the first Philadelphia Salon in 1898 and his editorship of *The American Photographer* and *Camera Notes*. Caffin entered the melee when his review of the 1898 Philadelphia Salon in *Harper's Weekly* contained a scathing criticism of Stieglitz. Stieglitz recalled to Nancy Newhall that after he had read Caffin's criticism of himself, he was approached by the editor of *Everybody's,* Wanamaker's house organ, and asked to do a series of articles on photography. Stieglitz's reply was that he was no writer and he recommended that Caffin be asked to do the series. Soon after, Caffin came to Stieglitz in bewilderment about both the proposal and the source of the recommendation, whereupon Stieglitz offered to give Caffin any information he needed, with the exception of information about the actual photographs. It was then that Caffin really looked at the photographs, and his subsequent articles reflected a changed attitude. Thereafter, Caffin and Stieglitz became close friends. When artists and photographers criticized his friendship with Caffin, asking why he tolerated "such an old fogey," Stieglitz invariably replied that Caffin was the only art critic who was utterly honest and who took the trouble to look at every picture before making up his mind.

Caffin already had long experience in writing about painting, sculpture and architecture, but this in no way guaranteed acceptance of his writings on photography. *Photograpy is not a fine art because it can invent nothing.* This, from *The Nation's* unidentified critic, was typical of the response to *Photography as a Fine Art.* Caffin implied in his book that the goal of art was the attainment of harmony and beauty, but *The Nation* dismissed this, saying: *It [photography] can give us a true record or a muddled and falsified one, and it can show the taste and judgment of him who selects the facts to be recorded.*

Fortunately for photography, Charles Caffin had more prescience than most of his contemporaries. Born in England and a graduate of Oxford University, he came to America in 1892 and remained until his death in 1918. Having arrived in the new world at the age of 38, he brought to his new experiences a maturity and a special sensitivity to what was democratic in the arts, combined with a flexible attitude towards the new. He explained his tolerance for what he humorously described as *the wholesome savor of Philistinism* in a 1904 article in *World's Work* entitled "How American Taste is Improving," saying: *It is a necessary ingredient of democracy and may save us from reaching that extreme altitude of artistic perfection on the other side of which is rapid descent.* In the same article he included illustrations of old and new Pullman car interiors, and almost fifty years later, John A. Kouwenhoven, in *Made in America*, described these same Pullman car interiors as . . . *a unique kind of folk art . . . a democratic-technological vernacular which has been overlooked* . . . Much of Caffin's other writing displayed this flexibility and sympathy, and he wrote understandingly about what he termed "The New Photography." Although he frequently compared photography with painting, he made these comparisons not to illustrate the inferiority of light-sensitive processes, but rather to discuss the integrity and suitability of these methods for obtaining better pictures than anyone had thought possible.

When we study this book and realize when it was first published, certain of Caffin's ideas and theories are significant. His recurring references to "accidental effects" and their creative use were anathema in 1901, but are now widely accepted in art. He spoke of "simplicity, synthesis and spontaneousness," and the implications of these words have grown tremendously since he wrote them. His application of these concepts to photography is yet another indication of the significance of his ideas at a time when the main concern of both photographers and the public was one of quantity over quality, or "how much will a dozen cost."

The entire range of photography and its critical problems are examined in this book: the questions of art versus record straight versus manipulated, color versus black and white, picturesque versus conceptual — all are analyzed and discussed with great sensitivity and understanding. But Charles Caffin was not attempting to make definitive critical judgments. His many books which, in addition to *Photography as a Fine Art*, include *American Masters of Painting*, *American Masters of Sculpture*, and *How to Study Pictures*, were designed to have a broad popular appeal, in fact, *How to Study Pictures* first appeared in serial form in *St. Nicholas Magazine*.

Caffin was not attempting to construct the definitive critical judgment for his time or for ours. He strove constantly to provide a criticism that would meet the demands of democracy and the art created by that democracy. Perhaps Charles Caffin stated his philosophy of criticism most succinctly in his article, "The New Photography," in *Munsey's Magazine* in 1902: *There is opportunity for guesswork as well as for assurance, which is precisely the way in which we get our own impressions of life.*

<div style="text-align: right">

Thomas F. Barrow
Rochester, N. Y., 1971

</div>

PHOTOGRAPHY AS A FINE ART

A PORTRAIT, BY J. CRAIG ANNAN

PHOTOGRAPHY AS
A FINE ART

The Achievements and Possibilities
of Photographic Art in America ❧
By CHARLES H. CAFFIN

Illustrated

NEW YORK
DOUBLEDAY, PAGE & COMPANY
1901

INTRODUCTION

Everyone recognizes the modern improvements in photography, but very few are aware of the direction and scope of its best developments. They know what respectable results can be obtained by the amateur and how superior the print exhibited on Fifth Avenue is to that displayed in the Bowery; but do not realize that anything more artistic is being attempted and achieved by men and women who are seeking to lift photography to the level of one of the Fine Arts.

This group of " advanced photographers " is striving to secure in their prints the same qualities that contribute to the beauty of a picture in any other medium, and ask that their work may be judged by the same standard. This claim involves two necessities: first, that the photographer must have as sound a knowledge of the principles of picture-making as the painters have; and, secondly, that it is within his power, as well as theirs, to put personal expression into the picture. It is not enough that he shall be an artist in feeling and knowledge, but that he shall be able so to control the stages of the photographic process that the print at last shall embody the evidence of his own character and purpose, as an oil-painting may do in the case of the painter. That this is possible has been either ignored or denied. The original intention of the following chapters was to establish this possibility and thus substantiate the claim of the

INTRODUCTION

advanced photographers that their art could be practised
with such purposes and results as to place it among the
other Fine Arts.

Beginning with a consideration of *persons*, the book
has grown more and more towards a consideration of
principles. It evolved itself that way and, perhaps, not
unfitly ; for an understanding of the principles is necessary
to an appreciation both of what these photographers are
aiming at and of what they have achieved, as well as of
the further possibilities within reach of the art. Neces-
sarily, it was only a summary of the principles that could
be attempted and the utmost that the book can lay claim
to is a possible suggestiveness. It may, perhaps, lead the
general reader to look for something more in a photograph
than a good likeness or accurate record of a landscape ;
may stimulate some photographers to a higher appreciation
of the possibilities of their art and may even incline the
painters to include a few photographers within the pale of
the artistic brotherhood.

The first six chapters have been republished by permis-
sion of *Everybody's Magazine* and the seventh by the
courtesy of *Camera Notes*.

<div align="right">C. H. C.</div>

MAMARONECK, N. Y.

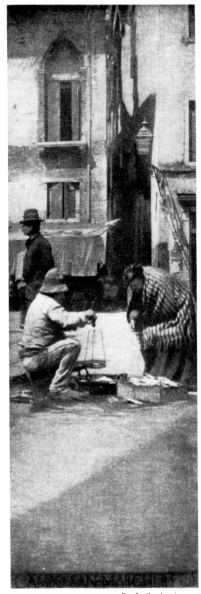

By J. Craig Annan

CAMPO SAN MARGHERITA

CONTENTS

LIST OF ILLUSTRATIONS

List of Illustrations—Continued

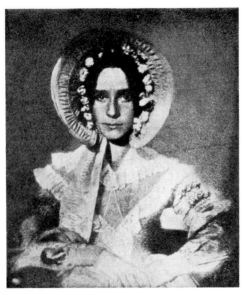

COPY OF THE EARLIEST SUNLIGHT PICTURE OF
A HUMAN FACE, TAKEN IN 1840.

PHOTOGRAPHY AS A FINE ART

CHAPTER I

THE DEVELOPMENT AND PRESENT STATUS OF THE PHOTOGRAPH

WITH PHOTOGRAPHIC EXAMPLES FROM THE EARLIEST PORTRAIT TO THE WORKS OF J. CRAIG ANNAN*

AN photography be reckoned among the fine arts?

The great French painter, Paul Delaroche, seeing an example of Daguerre's new light-pictures, is said to have exclaimed, "Painting is dead." So far the prophecy has not been fulfilled; and it is safe to say that painting has less to fear from the competition of photography than from its

*Mr. Annan, a Scotchman, is one of the most versatile and artistic of European photographers, a man of forceful personality, who has had a powerful influence in the development of pictorial photography.

own over-productiveness. The interest of the remark, therefore, consists in this—that Delaroche instinctively recognized in the new invention qualities and possibilities which would ultimately bring it within the pale of the other fine arts. It is a belief that has been cherished by photographers from the start, and it is the object of the present article to trace, first, the development of this belief into practice, and then to consider the possibilities and limitations of photography for picture-making and the salient characteristics of picture-photography as aimed at or reached by the advanced photographers.

It is not always good to be heralded into the world with a

EXAMPLES OF THE PHOTOGRAPHIC ART OF
THE FIFTIES

Daguerreotypes stiff in character and awkward in arrangement.
They were mounted in gilt frames and generally
enclosed in plush or leather cases.

flourish of trumpets, and the exaggerated expectations which the public formed regarding Daguerre's invention aroused the suspicion and animosity of the painters. This changed to contemptuous indifference as it began to be understood that photography had its limitations. The pendulum had swung to the opposite extreme, the art side was ignored and the process dismissed into the limbo of chemistry and mechanics. The one attitude was as unreasonable as the other. Moreover, photography as an art fell upon evil times; it was seized and exploited for moneyed ends, and its artistic possibilities became obscured by commercialism. With the usual interacting of cause and effect, the photographers aimed to please the public, and the latter accepted their work as representative of the art at its best. Dip into the family album of twenty-five years ago; you will see the mediocrity that prevailed under these conditions. Here and there a print will record a good likeness; but, for the most part, appear examples of persons, posed in painful attitudes, amid surroundings execrable in their ugliness; the faces purged of every blemish and presenting surfaces as smooth and unlifelike as a fresh cake of soap. Or one's researches may be carried further into that realm of bathos, peopled with the make-believes of the pictorial photographer; models, clad in cheese-cloth, masquerading as angels, madonnas, fairies or classic heroines, or the thousand and one " creations" of the uncultivated photographer, who either had no sense of humor or carried his tongue in his cheek at the credulity of the public.

Yet it would be unjust to dwell too insistently on these points, still more so to saddle photography with the entire responsibility for its own shortcomings. The

period under notice was one of banality in all the arts. A few names of painters and sculptors stand out as eminences, but for the most part the two arts showed a dead-level of mediocrity. This is as true of Europe, with its uninterrupted traditions, as of America, which was just commencing its art-consciousness. And it is equally true to say that, although higher standards are now understood and recognized, a vast mass of pictures and sculpture is still annually produced which has no reason for existence except that it is made to sell. Its motive is commercial, and commercialism its only justification. But both these arts have a noble past and dignified traditions, which a faithful few are resolute to maintain, while photography is even now engaged in establishing its dignity and in storing for itself traditions. All the while a few enthusiasts, disregarding the allurements of popularity and full of belief in the possibilities of their craft, have steadily worked to produce photographs which shall appeal to the cultivated judgment as truly pictures.

A TYPICAL PORTRAIT OF THE
SIXTIES

At this period photographs were usually made about the same size as these reproductions, and were mounted on small cards.

For a time the Photographic Society of Great Britain, now known as "The Royal," afforded at its annual exhibitions opportunity for the display of artistic work by photographers in all parts of the world. It conferred awards,

and the highest was regarded as the Blue Ribbon of the art. Gradually, however, the Society "grew lax in its methods and did not insist on the highest standard." The earliest protest arose in Vienna, when certain photographers, braving the sneers of the conservatives, organized, in 1899, the Viennese Photographic Salon. Its success was so pronounced that it brought to a head the discontent felt in England with the unprogressiveness of " The Royal;" the result being a secession of some of the members and the formation of the now famous " Linked Ring." This differed from the Viennese Salon in two important respects. While the Salon had adopted a system of awards, the " Ring " dropped them altogether, determining

A COMPANION PORTRAIT OF THE SAME PERIOD

to maintain a standard so high that the mere admission of a picture to the exhibitions should be in itself an award of honor. Again, the Salon had entrusted the selection of pictures to a jury of painters; the " Ring " reverted to a jury of photographers; for it argued, quite reasonably, that the latter were, or ought to be, as capable of judging the pictorial qualities of a picture as the painters are; that they, moreover, understood the technical possibilities and limitations, while the painters did not, and, still further, that they regarded photography in all seriousness, which,

as yet, it was not at all certain that painters, as a class, did. The "Ring," then, was formed to uphold the highest possible standards in picture-photography, and,

A STIFF MODERN PHOTO
The style of print which has passed for fine work
in the best galleries

being anxious to avoid the least chance of itself falling by degrees into set grooves, it refused to shackle itself with a constitution or even to have officers. Originally composed of some thirty members of various nationalities, it has grown, through the election of those who have made distinguished showing at its exhibitions, to rather more than double that number ; including in its membership the following Americans : Alfred Stieglitz, R. Eickemeyer, Jr., F. Holland Day, Joseph T. Keiley, Clarence H. White, and Mrs. Gertrude Kasebier, who is the first lady to have been enrolled.

The example of this annual Photographic Salon was followed shortly in Vienna, Paris, Hamburg, Munich and other European cities; "till, finally, pictorial photography came to be taken seriously by the continental Art Societies and Academies, and today the principal photographic exhibitions are held under their auspices, and in several art centres the leading art museums have established permanent exhibitions of original photographs of real artistic merit and value, and have set aside a fund for the purchase of the same." The latest salon, the Philadelphia

PHOTOGRAPHY AS A FINE ART

Photographic Salon, was organized under the joint direction of the Pennsylvania Academy of the Fine Arts and the Photographic Society of Philadelphia in 1898.

Up to this time there had been no dearth of photographic societies in the United States, or of exhibitions; but their artistic standards were poor, for the facilities of the cheap camera had been and still are prolific of mediocrity. Even the joint annual exhibitions, held in turn at New York, Philadelphia and Boston, from 1884 to 1894, which were modelled to some extent on the Photographic Society of Great Britain, gave no encouragement to the principles and efforts of the advanced photographers. The latter have been represented in this country by a small and steadily increasing group of earnest workers, whose work will form the subject of subsequent articles in this series. For the present, it is enough to say that their leader has been Alfred Stieglitz, well known throughout the photographic world, who has been closely identified with each stage in the development of the art during the past fifteen years. Both in his pictures and in his writings, as well as by his personal influence, he has, little by little, in face of a dead inertia of indifference and of the more active opposition of misconception and ridicule, upheld the hands of the artistic photographers

AN "ARTISTIC" PORTRAIT
" A favorite pose "

and won recognition for the art. The result of his efforts in this country has been the establishment of the Philadelphia Photographic Salon, at which no awards are made, admission to the exhibition being held sufficient honor ; while the test of selection is that the work, to be accepted, must show "distinct evidence of individual artistic feeling and execution." It remains to be seen whether the Management of these exhibitions will have enough courage of its convictions to maintain this principle. If there is any wobbling of purpose, and the high standard now professed is for any reason relaxed, the exhibitions will immediately lose all claim upon serious consideration.* On the other hand, the character of the

BUCOLIC PHOTOGRAPHY
An excellent representation of the photographic art as practised in the smaller towns

best work in this country is so good that, with staunchness to principles and patience under opposition, the Philadelphia Salon may soon become the most distinguished in the world.

Such is a brief account of the movement that has been started and maintained by the vanguard of photographers to make the picture-photograph pictorial in the highest sense. It remains now to describe the characteristics of the best

*Already, since the above was written, an attempt has been made to "popularize the Salon !

picture-photographs, and, incidentally, to touch upon the possibilities and limitations of photography in this direction.

There are two distinct roads in photography—the utilitarian and the æsthetic; the goal of the one being a record of facts, and of the other an expression of beauty. They run parallel to each other, and many cross-paths connect them. Examples of utilitarian photographs are those of machinery, of buildings and engineering works, of war-scenes and daily incidents used in illustrated papers, of a large majority of the views taken by tourists, and of the greater number of portraits. In all these the

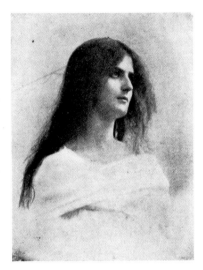

PROFESSIONAL " HIGH ART "

This photograph was awarded the prize in a beauty contest in Paris

operator relies upon the excellence of his camera, and in developing and printing aims primarily at exact definition. Examples of the intermediate class are photographs of paintings, sculpture and architecture, which, while first of all useful as records of works of art, are treated with so much skill and feeling for the beauty of the originals that they have an independant value as being themselves things of beauty. Preëminent in this class is the portrait, which gives a truthful record of the individual's characteristics, at the same time being so handsome as a picture that we enjoy it apart from any consideration of its being a good likeness. Lastly, there is the photograph whose motive

is purely æsthetic: to be beautiful. It will record facts, but not as facts; it will even ignore facts if they interfere with the conception that is kept in view; just as Corot in his paintings certainly recorded the phenomena of morning and twilight skies and just as certainly left out a number of facts which must have confronted him as he sat before the scene, his object being not to get at facts, but to express the emotions with which the facts affected him.

The point to be noted is that, while in the first class the photographer succeeds by mechanical and scientific means, in the two latter he must also have sympathy, imagination, and a knowledge of the principles upon which painters and photographers alike rely to make their pictures. He must understand the laws of composition, those also which affect the distribution of light and shade; his eye must be trained to distinguish " values," that is to say, the varying effect of light upon objects of different material and the gradual changes in the color of an object according as it is nearer to or farther from the eye. These involve technical knowledge which may be acquired; in addition there must be the instinctive sense of what is beautiful in line and form and color, which may be developed by study, and, lastly, the natural gift of imagination which conceives a beautiful subject and uses technique and instinct to express it. The contention of what we have called the " advanced" photographers is that these qualities of temperament and training must be brought to the making of a picture-photograph. They are identical with the equipment of a painter, except that he learns to use color and, if he is a true colorist, thinks in color. But no stress need be laid on this exception; for, in its present inability to reproduce color, photog-

THE BLACK CANAL, BY J. CRAIG ANNAN

An excellent example of the possibility of obtaining unusual effects in photography. The treatment of the water has the value of a fine etching

raphy stands along side of etching; nor must we forget that a good "black-and-white," though it does not state the colors of a scene, has a power of suggesting them, which also reminds me that sculptors speak of a statue as being good in "color" when they wish to commend its distribution of light and shade. So we reach the point that the most important difference between the painter and the photographer is in their respective tools. While the former uses a brush or knife or his own thumb to cover his canvas, a needle to scratch his etching, or a burin to engrave his plate, the latter uses a dark-box with a lens in the front of it. The painter who affects to despise photography—except, by the way, as a short cut for obtaining studies of his models—might condone the dark-box, just as he has been accustomed to paint nature's sunlight while sitting within the four walls of his studio, lighted from the sunless north; but he calls a halt on the lens. That is mechanical, substituting a soulless eye for the artist's individual vision.

The reader will notice that this objection involves two propositions: first, that the camera is mechanical; secondly, that the use of it prevents the artist's individual vision. We may admit the one without subscribing to the other. Undoubtedly the camera is mechanical, and that is the limitation under which the photographer labors. But every art has its limitations. The architect is confronted with problems of construction, with local conditions and the need of satisfying required utilities— all of which hamper the freedom of his artistic invention. The conscientious painter laments the inadequacy of pigments to express what he sees and feels, and, except in rare instances, finds the handling of his brush an obstacle

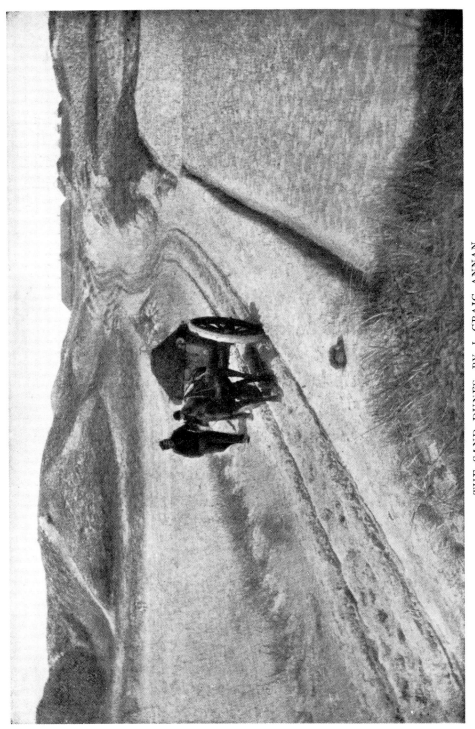

THE SAND DUNES, BY J. CRAIG ANNAN

A particularly successful and sincere specimen of modern pictorial photographic art

to freedom of expression; while the sculptor knows better than anyone the difficulty of manifesting life and movement in inert marble or bronze. Each art is shackled with material fetters, and the pride of the artist is in rising despite them. With brush and pigments the painter-artist can accomplish something infinitely superior to the work of the house-decorator. Is he blind to the immeasurably superior results reached by the artist-photographer over him who merely relies upon the mechanical facilities of the camera?

We shall better appreciate these results by thoroughly realizing the limitations which the camera imposes. They make themselves felt particularly in figure-work. Consider the simplest case, where the picture is to consist of a single figure. Both painter and photographer work from a model; but the former can correct, modify, and above all put into the face such expression as the subject demands. The photographer on the contrary, though he may talk the subject into his model's brain, may find himself disappointed of success by the impossibility to make the model express it. Particularly is this true of the regular professional model, who, ordinarily, is not expected to do any thinking, and who is also apt to be too sophisticated to assume even a natural expression. It is in this respect that children afford the happiest results, especially if they can be caught, as it were, in their free wildness. The difficulties hinted at in the single figure composition are increased in the case of groups. Rarely does one see a photograph, containing many figures, in which the lines retain their suppleness throughout the composition or in which there is a complete uniformity of feeling pervading the whole picture, unless the group is treated in the

middle-distance rather than the foreground. It is in this way that the prudent photographer often prefers to use figures, or he will rely upon the movement rather than the expression. Especially, he is inclined to make the motive of his composition decorative, using the human figure as part of an ornamental arrangement of lines and masses of light and shade.

What we have said of the figure-picture is practically true of the portrait. The painter enjoys the opportunity of studying his subject's character and characteristic pose and expression in many sittings, and can gradually elaborate the record of what he sees, striving to make it comprehend or suggest the many-sidedness of his subject. This, however, is a great gift, and few there be that find it; but it constitutes the grandeur of the great portraits of the world. I have heard of a photographer inviting to his studio some one whose portrait he wished to take, and on many occasions in the unrestraint of conversation studying his characteristics, and then one day, by a little ruse, securing a negative-plate when the subject thought it was something at his side that was being photographed. But this is obviously impracticable as a rule, and the photographer must ordinarily rely upon quickness of sympathy and comprehension, upon his ability to cultivate confidence at short notice, and the power of rapid decision as to pose and lighting, so that he saves the sitter the oppressive feeling of being operated upon. One can imagine the difficulty of this, and it is surprising how the best photographers surmount it. There is another side to the portrait, which is that, besides being a good likeness, it may be a beautiful picture, and one is inclined to believe that in this respect the photographers succeed

more often than the painters. Indeed, one may go even further and assert that, in this country today, the portraits by the best photographers attain a higher average of all-round excellence than those by the best painters.

From what has been said it may be gathered that in photography the hardest of all figure-subjects is the study from the nude. Except in the case of children, the modern form is seldom sufficiently free from defects or able to pose and move naturally without the accustomed restraint of clothing. Still less is the nude model tolerable for any subject that involves expression of sentiment. Yet many photographers use it to good effect in subjects distinctly decorative; particularly in statuesque poses and with the emphasis on light and shade.

Another limitation encountered by the photographer arises from the impartiality with which the camera records anything near to it and the misinterpretation it gives to distances; whereas, when, we look, for example, at a landscape, our eye, on the one hand, is conscious of successive planes of distance, and, on the other, is unable to grasp more than the salient features. So the landscape taken by an untrained photographer may be a very pleasant reminder of a beautiful spot, but it will not be true to nature, and it will be so crowded with facts as to lack the simplicity and synthesis of pictorial composition; a charge, by the way, which may be brought against many painted landscapes. Before considering how photography surmounts this limitation, let us note that in certain branches of photographic work it is a quality of value. One has seen, for example, some studies of birds and flowers in which the fulness of detail and suggestion of the actual texture were beautiful in themselves as

well as valuable for truth. The painter obtains his synthesis by elimination of the unessential and massing of the important features. The photographic artist does practically the same. He studies the landscape until he has found the point of view from which it most impresses him; then he discovers the time of day and the atmospheric conditions most conducive to the impression he wishes to record. Perhaps he selects the moment when a broad shadow or a flood of light stretches across the foreground, with the effect of unifying it. Having made his negative, he is able in the processes of developing and printing to control the result—strengthening this part or reducing that until he gets the planes of his picture truthful, and reaches synthesis. In a word, those who have studied the work of the advanced photographers realize their ability to make a picture that is large in conception and beautiful in feeling, notwithstanding the limitations of the camera.

It will be recognized at once that such work as this, in landscape or in figure, demands artistic temperament and training, and involves a large expenditure of time and labor. And now we arrive at a definition of what we have been calling the "advanced" photographer; he has the temperament and training and is so devoted to his work as to expend on it patient study, time and labor.

Lastly, can he infuse an individuality into his pictures, as the painter can, making them express his own personal conceptions of beauty? For answer we need only refer you to the work of the best photographers. You will find a kinship of feeling throughout all the examples of any one, so that you would know an isolated example to be by So-and-so; and, on the other hand, that his work

differs from that of the others as theirs from one another's. In short, if he has the equipment of an artist and an artistic individuality, the photographer can surmount or evade the limitations of his mechanical tool, the camera, and produce work which, barring colors, may have the characteristics of a beautiful picture.

In a word, Saul also is to be reckoned among the prophets.

CHAPTER II.

PORTRAIT OF MR. R., BY ALFRED STIEGLITZ (1895)

(From a platinotype)

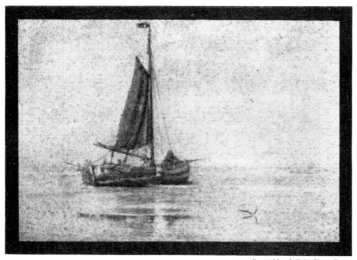

AT ANCHOR *By Alfred Stieglitz, 1894*
(From a gum-print in India ink on rough drawing paper)

CHAPTER II

ALFRED STIEGLITZ AND HIS WORK

WITH A REFERENCE TO THE "STRAIGHT" AND "MANIPULATED" PRINT

HERE are few, if any, who will not concede to Alfred Stieglitz the first place among American exponents of pictorial photography. It is his own, both for what he himself has done, and also for what he has encouraged and enabled others to accomplish.

His influence upon the progress of the art has been so widely diffused that it is difficult to estimate it accurately. We have to consider him as an artist, following his own ideal, and reaching certain definite results of personal expression—but as much more than an individual factor; by his training and affiliations a connecting link between the photographers of Europe and of the United States—as a man

23

of international influences; then, again, as a vitalizing force in the betterment of the art in this country, one whose wide knowledge and large sympathies have been ever at the call of those who are earnest workers, and always with an ardor entirely unselfish. In fact, he has been the incarnation of the movement—artist, prophet, pathfinder.

He is an American by birth; born in 1864. In 1881 he went to Germany to study mechanical engineering in the Polytechnic Schools at Berlin. His object up to this time was purely scientific. However, the famous scientist, Professor Vogel, Chief of the Photo-Mechanical Laboratory, suggested a course of theoretical photography as of practical value in engineering. Mr. Stieglitz was one of those who fell in with the idea and had the benefit of work-

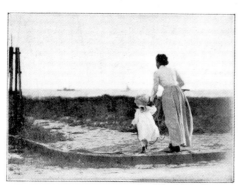

By Alfred Stieglitz, 1900
GOING TO THE BEACH
(From the " Photographic Journal of a Baby ")

ing under the professor while he was developing his invention of ortho-chromatic plates and reducing his results to a commercial possibility. The object of these " corrected color" plates was to counteract the tendency of certain colors in nature to assert themselves at the expense of others; to discover, in fact, a solution which should render the plates sensitive to all the colors in their balanced relations, translating them into a truthful equivalent of black and white. Thus for two years Mr. Stieglitz assisted in the experiments, photographing all kinds of subjects— landscapes, flowers, portrait paintings, and so forth, and he

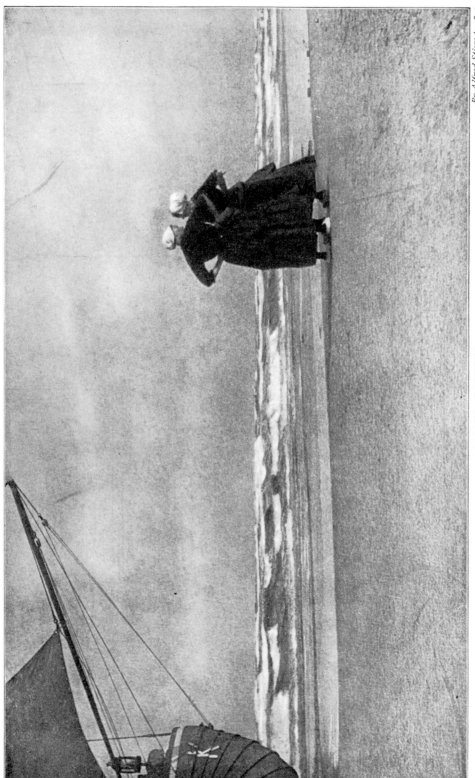

By Alfred Stieglitz, 1894

GOSSIP—KATWYK

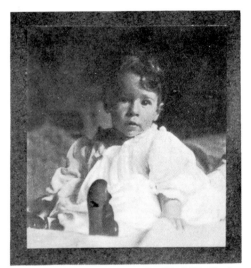

By Alfred Stieglitz, 1899
MORNING

was probably the first amateur to use these "color sensitive" plates in his own work. During this period the passion for photography asserted itself over his original intention of being an engineer. It satisfied alike his love of science and a natural instinct he found he possessed for art. After two years of close scientific study he started, camera in hand and his wallet filled with these ortho-chromatic plates, for a

tour through Italy in search of the picturesque. He seems to have looked for it and found it, particularly in its relation to the outdoor life of the people. One of the first of these Italian studies was *A Good Joke*, which he sent to a "holiday work competition," organized by *The Amateur Photographer* of London. It was awarded

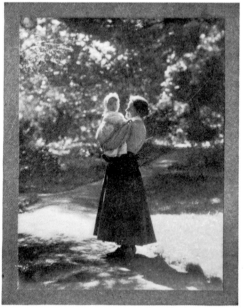

By Alfred Stieglitz, 1899
NOON
(All three from the "Photographic Journal of a Baby")

first prize, the judge being Dr. P. H. Emerson, subsequently well known as the author of *Naturalistic Photography*, who said of the print that it was the only spontaneous work in the whole collection. I shall return to this picture presently. Apparently its recognition confirmed Mr. Stieglitz in his devotion to

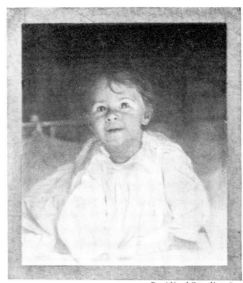

By Alfred Stieglitz, 1899
GOOD-NIGHT

photography, and, very characteristically, he returned to Germany and entered upon the study of chemistry, meanwhile keeping up a correspondence with the leading photographers of Europe, writing on the science for German periodicals, and winning prizes at many exhibitions. In 1890 he returned to the United States, continuing his scientific investigations; sending pictures to exhibitions all over the world; being elected a member of the famous "Linked Ring" in England, and winning nearly a hundred honors of various kinds; acting for a time, without remuneration, as editor of *The American Amateur Photographer*, and stimulating through the country a higher standard of aim and accomplishment; for some time filling the position of manager for a photo-engraving company; helping to organize the Camera Club, and assuming the responsibility for and editorship of *Camera Notes*, the most dignified, and probably most influential, of all photo-

graphic journals; finally taking a leading part in the establishment of the Philadelphia Photographic Salon, and holding today a unique position of leader, counsellor and encourager, to whom the only introduction needed by other amateurs is that they also have the interests of pictorial photography at heart.

In this elaborate web of energy two qualities are clearly perceptible—the scientific and the artistic temperament. They represent the warp and woof; and, if one is to assign their relative positions, I am inclined to believe that the foundation threads of his purposes are scientific, and that into these he has woven the artistic woof. But the two are so closely matted that their discrimination is of little practical value; the main thing being that they are adjusted to a most admirable balance, and that the enthusiasm which is characteristic both of the scientific and of the artistic temperament is in him united. In this dual interest we discover the secret of his own personality as an artist, and of his influences upon the purposes of photographic art.

There is no inherent antagonism between science and art, as some people rashly imagine; regarding the former as fastened down to measured footsteps of accuracy and logic, while art proceeds by leaps and bounds. Our great artist, John La Farge, for example, has reached his splendid results of color, both in painting and stained glass, by making science his handmaid; Pissarro, Monet and Sisley, the most famous of the "Impressionists," have done the same, the first named attributing his earliest inspiration to the scientific discoveries of Professor Rood of Columbia University; while architecture is largely an adjustment of artistic motive to scientific possibilities. But the alliance

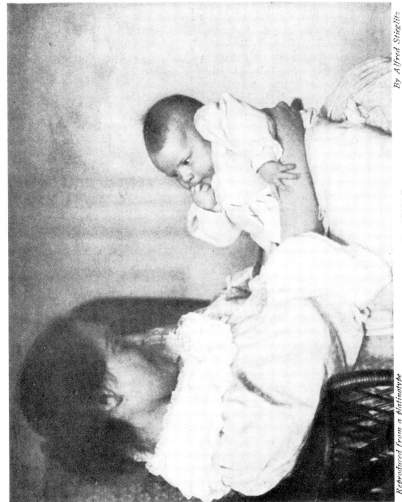

Reproduced from a Platinotype

By Alfred Stieglitz

MOTHER AND CHILD

(From the " Photographic Journal of a Baby")

seems even closer in the case of photography; for it has its base in chemistry and physics, and only upon these can one rear an artistic superstructure, independent of the other arts. It is impossible, therefore, to overestimate the value to this new art of having had a champion fully equipped in both directions; one who could comprehend the artistic possibilities, and reach them through scientific investigations, making himself not merely a prophet of ideas, but a pathfinder toward their realization. Moreover, Mr. Stieglitz has been perpetually a counterpoise of sanity, resisting the tendency to run after strange gods, to indulge in "faked" effects, and to consider that the end always justifies the means.

"Faked effects" may sound a strong term, but with what other can one describe the old so-called "moonlight" scenes which were taken in *full daylight* with the camera pointed at the sun, occasion being chosen when a passing cloud veiled the intensity of its glare? An effect was obtained which unquestionably suggested moonlight; but failed entirely to render the mystery of night, the subtle pranks which the lights and shadows play. In fact, it was not a picture of moonlight, but of something that to the thoughtless and easily satisfied might seem to be "just as good"—not a record of nature, but a fake. Very often it was an extremely pretty one, and to a great many people prettiness represents the limit of their comprehension in art. So these "moonlights" pleased, and the discovery that they were faked lent a further zest. The "Who'd have thought it?" followed on the "Oh! my, how pretty!" and that curious trait of human nature, recognized by Barnum, was satisfied. But an artist is not satisfied with prettiness; he searches for beauty, and, in his study of

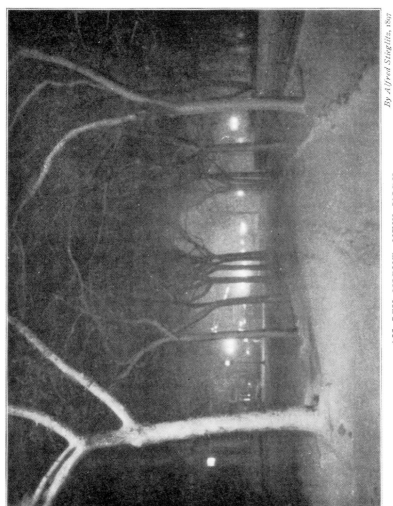

AN ICY NIGHT, NEW YORK

By Alfred Stieglitz, 1897

nature, finds it through truth to nature. The only moonlight picture that could begin to satisfy him was a picture of moonlight. Experimenting in this direction, another artist, Mr. Wm. A. Frazer, succeeded in obtaining moonlight landscapes at night with an exposure of some ten

By Alfred Stieglitz, 1900
THE AFTERNOON VISIT
(From the " Photographic Journal of a Baby ")

minutes. This, of course, precluded the introduction of moving objects, and Mr. Stieglitz pushed his investigations still further until he was able to take a rapid picture of a street at night, animated by vehicles and pedestrians. He has made a present of this discovery, as of his other ones, to the photographic world; for he is an amateur in the strictest sense of the word, impelled only by a love of his art and a desire for its advancement; devoting any money that remains from the sale of prints to further research, the results of which in time become public property.

PHOTOGRAPHY AS A FINE ART

In this connection allusion may be made to the propaganda he has maintained by voice and pen. His correspondence with photographers throughout the world and contributions to periodicals, apart from his editorial work, have been continuous and influential. His writings are terse and to the point; backed with so much knowledge and so disinterested that they command respect even from those who are disinclined to accept his views. There are heartburnings among photographers as among co-workers in other lines, and Mr. Stieglitz has received a full share of knocks from opponents, but I doubt if there is a single one of the latter who does not heartily respect him even while he thumps him. He also is an accomplished thumper; delivering his blows with telling directness, the effect of which it is difficult to explain away. For it cannot be said that he has any private ends to serve, or that he is merely an artistic visionary, or, on the other hand, that he is only a scientist with no feeling for art. So he is a troublesome antagonist, and even those who resent his *de facto* leadership among American photographers are bound to admit that he has not sought the honor, but that it has grown around his personality through his qualifications fitting so admirably the circumstances and needs of the time. Moreover, it is not only by direct exertion of his talents that he has reached his position. People approach him in various ways; to secure his pictures at exhibitions and himself as a juror; to have him lecture; and to seek his advice in problems with which they are wrestling. Thus, he has had forced upon him the *role* of spokesman and counsellor, and in both capacities is actuated simply by what he conceives to be the best interests of the art to which he has devoted his life.

It was mentioned above that he has always combated the doctrine that the end justifies the means. His attitude upon this subject is that the photographer should rely upon means really photographic; that is to say, upon those which grow out of and belong to the technical process. For example, he objects to the "touching up" of a negative by taking out the high lights or by deepening shadows, because this imparts a foreign element. The operator ceases to rely upon the actual scientific process and is "getting around" the deficiencies of his plate or of his own skill by what is, after all, a subterfuge. He does not deny that in certain cases a beautiful effect has been obtained, but, detecting the trick, feels a jar. The picture is not exclusively a photograph. On the other hand, he advocates and practises the fullest control of the result, both in the way of emphasizing certain parts, and of reducing or eliminating others. The gist of his argument consists in the fact that through the modern improvements in developing and printing, the operator not only has almost unlimited control over the result, but even can metamorphose the original. One sees photographs, for example, which look as if they were charcoal drawings, etchings, or wash-drawings; the photographer with brush or needle having simulated these effects. Of these Mr. Stieglitz would be disposed to say: "Yes, they are beautiful as pictures, but do not ask me to regard them seriously as photographs. If a man wishes to get a charcoal effect, let him use charcoal; why burden himself with the restrictions and difficulties of the camera, when he can accomplish his purpose so much more readily and effectively with a bit of burnt wood?" His friend might reply: "I am seeking certain results; the

By Alfred Stieglitz, 1898

A STUDY IN TWO COLORS

(Reproduction from a glycerine print in two colors—the process improved by Messrs. Stieglitz and Jos. T. Keiley.)

means are immaterial; I use photography as the readiest to my hand, but do not regard her as a mistress with divine rights, but as a servant to do my bidding." "But there are servants and servants," Mr. Stieglitz would rejoin, "Some learned in horses, some in the mysteries of the toilet, others in the cooking of cutlets—and reason would suggest relying upon their individual capacities. The arts equally have distinct departments, and unless photography has its own possibilities of expression, separate from those of the other arts, it is merely a process, not an art; but granted that it is an art, reliance should be placed unreservedly upon those possibilities, that they may be made to yield the fullest results."

As chronicler in these pages of our leading photographers, I do not take sides in the controversy; preferring to adopt the non-committal attitude of the theological student who, when he was asked to distinguish between the "major and minor prophets," humbly replied: "Far be it from me to draw distinctions between such holy men." But, whatever may be the merits of the case, it must be admitted that this doctrine of photography for photographers, so ably and staunchly maintained, has been most opportune and useful.

The art is new; its road is being gradually laid, "slowly broadening down from precedent to precedent," and the tendency of men, seeking for individual manner of expression, is to wander off the track. The influence of Mr. Stieglitz has been the conservative one of insisting upon the value of the main road, while his scientific knowledge and his own artistic productions have kept him in the van of those who are continually pushing it forward.

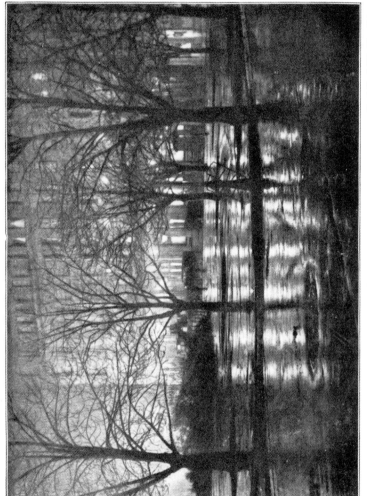

REFLECTIONS—NIGHT, NEW YORK

(First night photograph made with the introduction of life)

By Alfred Stieglitz, 1896

In common with all the best photographers, he lays great stress upon the mounting and framing of the prints. Size, shape, color, and texture of the mount and the color and character of the frame are all considered with a special regard for the color and character of the print, so that a complete harmoniousness may be obtained. In this respect the photographers as a body have shown themselves more artistic than the painters, who are gradually realizing the inappropriateness of most of the gilded abominations in which they frame their pictures. These are generally made in factories by artisans, skilful enough, but having no artistic sensibility, or, for that matter, any chance of displaying it if they possess it, since the frames are not designed for the pictures, but turned out in patterns which aim mainly at elaborateness of commonplace ornament and excessive glare of gilt. How often does one see such incongruity as the face of a maiden with sweet, wistful eyes peering out of a frame bedizened with the vulgar trimmings invented in the ostentatious court of the Grand Monarch; or a tender landscape, whose delicate atmosphere is sucked up by the hot glare of gilt around it. Such inartistic anomalies are common enough in every gallery of paintings, but rarely seen in a photographic exhibition. The reason is that the photographers have more completely realized the beauty of *tone;* and this from the nature of their craft. For, whether they print their pictures in gray, black, brown, or some other tint, they are practically limited to one color and must obtain variety and harmony by playing upon subtle gradations from the darkest to the lightest parts. One may compare the virtuosity of the violinist who, in the sweep of his bow over a single note, can produce robust-

ness of sound and a variety of differently modulated
expressions, dying away into tremulous vibrations. We
say he is extracting *tone* from his instrument, and by
analogy apply the same word, tone, to the artist's manage-
ment of his single color. Tone is equally applied to
similar management of many combined colors. The
photographer's feeling for tone does not stop short at the
edges of the print; he tries to make the frame con-
tribute to the effect by a harmony either of similarity or
contrast; by making the frame form one of the grada-
tions of tint, or by introducing into it another color that
will by contrast enforce the picture within. It is no
uncommon thing for a photographer to experiment for
several months with the framing and mounting of a
print; hanging it where he can see it frequently and
study it with a fresh eye, gradually amending his original
conception of the setting until it satisfies him.

As a key to the consideration of Mr. Stieglitz's own
work as an artist, it may be repeated that his prominent
characteristic is the balanced interest which he feels in
science as well as art. Interwoven with the artist's enjoy-
ment of beauty and the man's interest in human nature is
the expert's delight in seeing in his work the evidence of
scientific problems solved. He is by conviction and
instinct an exponent of the "straight photograph;"
working chiefly in the open air, with rapid exposure;
leaving his models to pose themselves, and relying for
results upon means strictly photographic. He is to be
counted among the Impressionists; fully conceiving his
picture before he attempts to take it, seeking for effects
of vivid actuality, and reducing the final record to its
simplest terms of expression. It will be remembered

that Dr. Emerson said of the print with which he won his first distinction that it was the only one in the collection which had spontaneousness. The subject of *A Good Joke* is a group of thirteen women and children standing near a water-trough in an Italian street. They are engrossed in doing nothing in a manner charmingly Italian, and a laugh is rippling from face to face, started, one may suspect, by the artist. It represents a vivid moment of actual life. So far it is impressionistic. But in this early picture there seem to be evidences that the figures were posed by the artist. If that be so, he has long abandoned the practice. He takes snap-shots, but does not touch the button until he has completely thought out the pictures, studied exactly the scene, conditions of light and position of the figures, and then bides his time until the conditions are possible, and then again waits for the figures, unconsciously, to pose *themselves*. The only chance upon which he depends is the one of eventually getting his figures in the place and pose that he desires. If that does not happen neither does the picture. Another fault of that early picture is its lack of condensation. It brims over with interest, but the interest is too scattered. Each face is a capital study, and the eye wanders from one to the other; this very diffusion of interest interfering with a simple, unified expression of the whole group. In a word the scene is a literal transcript from nature, rather than an artist's pictorial impression of it. This is not a characteristic of Mr. Stieglitz's mature work, in which he invariably emphasizes the important facts of the scene, eliminating or moderating the less important, and bringing every detail into due subordination to a single effect of telling simplicity. A

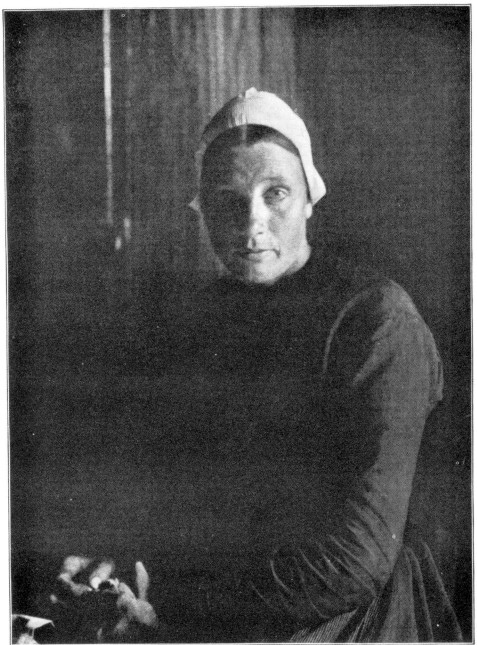

By *Alfred Steiglitz*, 1894

PORTRAIT OF A DUTCH WOMAN

very fine example of this is shown in the reproduction of *Gossip—Katwyk*. Before discussing it, however, we should remember that a "half-tone reproduction," no matter with what skill and care it be made, cannot render faithfully the delicate modulations of tone in the original print. The minute mesh of cross lines reduces the brilliance both of the whitest and blackest parts; tending to a general shrinkage in the range of tints or "values" and flattening the picture, with a resultant loss of distance and atmosphere. In *Gossip*, for example, the sky has been deadened, the vibration of light is scarcely represented, and its suggestion of atmosphere and breeziness much diminished. Moreover, the crests of the waves, and particularly the caps of the women, do not present the vivacity of contrast which is noticeable in the original.

But to return to the *Gossip*—how simple it is and what impressive realism in the simplicity! The broad sweep of open sky, the strip of waves following one upon another, and the stretch of sand, over part of which the water slides, are racy of free, fresh vastness. You may feel the scene to be a little drear, yet what invigoration there is, echoed in the sturdy forms and energetic action of the two women and the blunt strength of the boat. Boat, ocean, and wives, and a sense of isolation—the life and romance of a little fishing village admirably epitomized. The highest praise one can give the picture is to say that it reaches the heart of the matter with the same directness and sympathy that characterize the works of the Dutch artists Israels and Bloomers. One distinguishes these qualities again in *The Net Mender* and the *Portrait of a Dutch Woman*. They have the *intimate* feeling that usually Dutch artists alone can impart to Dutch subjects.

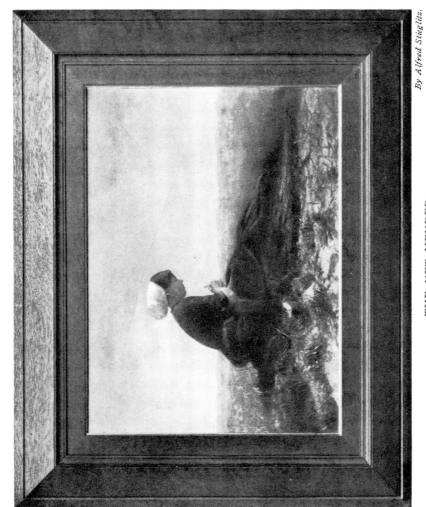

THE NET MENDER

By Alfred Stieglitz.

PHOTOGRAPHY AS A FINE ART

In the case of the portrait most strangers would have unduly emphasized the ruggedness of the face or the delicate linen cap, and insisted probably on the woman donning her gala attire, and have elaborated what they are pleased to call her "picturesqueness." But in his desire to reach the humanity of his subject Mr. Stieglitz has controlled his record masterfully. The breadth of the figure is felt rather than seen; our notice being drawn to the long, powerful arm; just enough definition is given to the cap to suggest its freshness and homely elegance; nothing is permitted to interfere with the strong, sweet earnestness of the face. This, too, is kept in control; the weatherbeaten flesh and massive skull being softened to a mystery of tenderness by the shadows, so that looking forth from her eyes is the soul of a woman, wholesome, strong and lovable. Nor let us omit the ample distribution of dark passages in the picture, knowingly diversified and spotted with the head and hands, the very pattern of black and white contributing to the expression of the woman's character. *The Net Mender* is a study of a type rather than of an individual, a familiar feature of the shore at Katwyk, seeming to belong to it as naturally as the tufts of grass, embodying even the spirit of the scene. The figure, notwithstanding its firmness, is supple and admirably adjusted to the spaces around it, and from edge to edge of the frame there is not an atom of jar upon the pensive tranquility of feeling that breathes through the picture. It is one that Millet might have conceived.

I wish that others of these Dutch pictures could have been reproduced, such as *Scurrying Home* and *Waiting for the Boats*, also other examples of the Italian and Swiss

series. It is in his treatment of the human subject in relation to outdoor scenes that Mr. Stieglitz has exhibited the most distinguished skill. Nor is he one of those who despair of discovering pictorial motive at home. The human nature which attracts him he finds most free from artificiality in the streets of cities. New York in its scenic and human aspects he has studied exhaustively, and one hopes that the results will some day be published, for they would give a record of city life without a parallel. Reproduced here are two of his famous series of night views of New York, one of them memorable as being the first night photograph made in which life is introduced. In both, the combined effects of brilliant and of diffused light are remarkable, and *An Icy Night* amply justifies his contention that a certain amount of " halation " (the muzzy halo surrounding some of the lights) is true to facts and pictorially pleasant. In this picture, also, one notes with what fine precision the reaching distances of the scenes are rendered. Considering the absence of light, the depth of the picture and the subtlety of its " values " are surprising. Another famous New York series is the one of snow scenes, of which a well-known example showed a Fifth Avenue stage ploughing through the newly-fallen snow; a picture fine in composition and in its suggestion of solemn desolation, full of atmosphere and wonderfully true in the receding distances of the waste of snow. Like all his work, it represents a conception thought out and vividly realized before the camera was set in place. In connection with these snow pictures there is an amusing story. One night he was awakened by a blizzard, and getting up and putting on many layers of clothing, crept from the house. He set

his shoulders to the storm and worked his way backward up the street; at one moment having his camera swept from his hands and carried far by the wind, but eventually obtaining a picture. Soon after daybreak, when the storm had cleared, other photographers began to arrive, to whom the policeman, emerging from his shelter, remarked: "Ah! you fellers ain't the first; there was a d——d fool here in the middle of the night." With one accord they exclaimed, "Stieglitz!"

No picture has secured its author more deserved reputation than the *Portrait of Mr. R.* One need not have known the subject to feel sure that it is a characteristic likeness of a most interesting personality; a man of mental power and tender qualities and, above all, of beautiful poise of character. One can read the last in the lean of the head and the carriage of the two hands, a pose at once spontaneous and reposeful; evidently habitual. Moreover, it is a handsome picture, rich in color-tone, with a noble simplicity in the distribution of light and dark and a gradation from the blackest to whitest that moves in a slow, impressive *crescendo*; the extremes of each meeting beneath the face and giving it additional distinction. The mingled firmness and mobility of the features and the soft luxuriance of the hair are exquisitely rendered. In fact, the more one studies the picture, the grander and sweeter it appears. It was achieved by the squeezing of a rubber bulb held *perdu* in the artist's pocket, for the subject did not know that he was being photographed. But it represents preliminary study extending over more than two years. The gentleman was habitually composed, but stiffened at once into unnatural self-consciousness at any suggestion of a sitting. Mr.

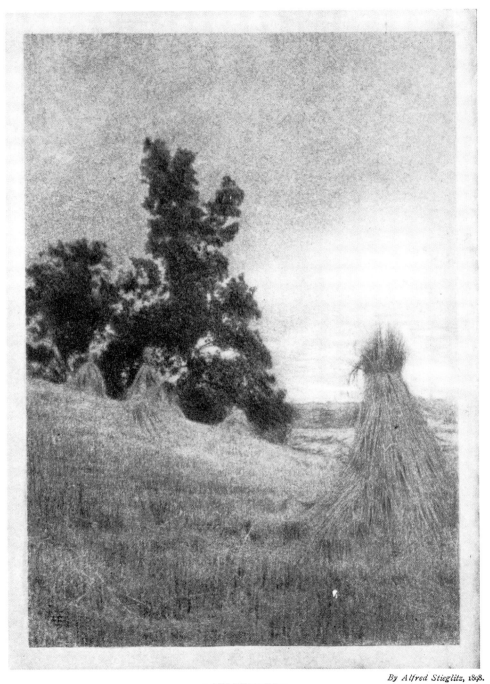

By Alfred Stieglitz, 1898.

"SEPTEMBER"

(Reproduced from a gum-bichromate print in India ink on tinted paper)

Stieglitz cultivated his friendship and studied his characteristics, until one day, during a summer visit to Lake George, he laid his plans for securing a picture. The camera was in readiness, facing a background of trees; for, little as one would suspect it, the picture was taken in the open air. The artist invited his friend for a stroll, chatting meanwhile of a picture he proposed to take. On reaching the camera, he expressed a doubt as to how much of a scene he should include, and begged Mr. R. to stand for a moment that he might compare the scale of the figure with that of the landscape. Without a suspicion the gentleman placed himself, assuming his accustomed attitude, and the next moment his portrait had been secured.

Devotion to art is most charmingly mingled with the personal element in a long series of pictures, still growing, entitled, *The Photographic Journal of a Baby*. Both the originality of the idea and the methodic completeness of its realization are eminently characteristic. The examples illustrated are not to be regarded as pictures; they are simply studies of baby life; artless, lovable incidents that had been watched and noted many a time before they were permanently recorded.

A word must be said of *Study in Two Colors*. In the original the face is a pale nut-brown, a savor of the same being appreciable in the lace. It is an example of the improved glycerine process perfected by Messrs. Stieglitz and Joseph T. Keiley, which enables the artist to increase or retard the development of the print and to introduce a coloring pigment. The intention here is not to present the color of the flesh, but to infuse an accidental note into the harmony of black and white.

PHOTOGRAPHY AS A FINE ART

In final summary of this appreciation of Mr. Stieglitz and his work, I would reiterate that the personal qualification, which has made his influence upon pictorial photography so widely felt and valuable, is the rare balance in him of scientific knowledge and artistic feeling, joined to a character enthusiastic, powerful and sympathetic. Regarding his pictures, one may end as one began with Dr. Emerson's word, " Spontaneousness." He excels in studies of human subjects, and in his best examples attains a realism that is no bare record of facts but the realization of a vivid mental conception. When he sets his figures in a scene they become part of it and one with it in spirit. He puts them there because he has seen that they belong to it. His sentiment, never degenerating into sentimentality, is always wholesome and sincere, and his pictures have the added charm of handsome arrangement and of simple and controlled impressiveness. In his hands the " straight photograph," in the broadest sense of the term, is triumphantly vindicated.

CHAPTER III.

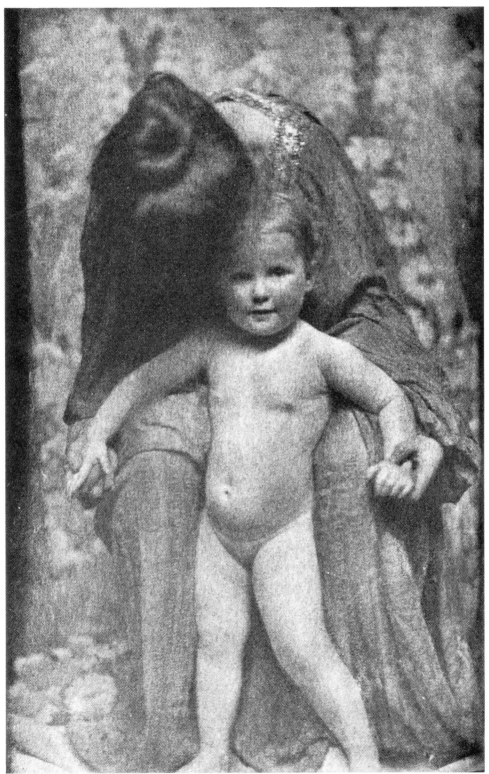

By Gertrude Kasebier, 1899

"DECORATIVE PANEL"

By Gertrude Kasebier, 1901
"GOING TO BOSTON"

CHAPTER III

MRS. GERTRUDE KASEBIER AND THE ARTISTIC-COMMERCIAL PORTRAIT

RS. KÄSEBIER will tell you that she is a commercial photographer; unquestionably she is an artist. The union in her work of these two motives forms a study of more than usual interest.

There are several kinds of commercial photographer, all united in the purpose of making a livelihood out of their work, but varying in the ideals which they set themselves. One will give his clients the least for their money, cheapening on material and process, so that the photograph will have not even permanency. Others,

55

either from honesty of purpose or because they are in a position to demand better prices, will use only the best instruments and materials and the most thorough process, so that their prints will stand the wear of time. Among the latter group are many who try in various ways to make their photographs pictures. Lastly, there are a few who succeed in this respect and produce truly artistic work. Preëminent among them is Mrs. Käsebier.

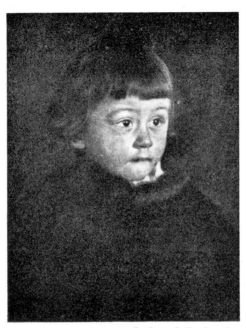

By Gertrude Kasebier, 1897
"PORTRAIT OF A BOY"

The portrait forms so large a part of her work that we will study her art particularly in this direction; and it is worth while just to try and reach a mutual understanding of what we mean by an artistic portrait, for really the sitter has a large share in determining the result. The photographer has to give his client what the latter desires or go out of business; so public taste may be a stimulus to him, while the lack of it acts as a constant drag upon the free play of his imagination and skill.

If one asks what is understood by a portait, the answer in nine cases out of ten will be "a good likeness." And this represents a very important quality; one that is sometimes overlooked by advanced artistic photographers,

who in their zeal to make an attractive picture will pay scant courtesy to the features. Yet, after all, to the friends of the person photographed it is, not unjustly, a first desideratum that the portrait shall be a good likeness.

But of what? A faithful representation of the features is not enough. Occasionally, it is true, one sees a face so faultlessly and regularly modeled that it has the beauty of a statue; almost always "it is icily regular, splendidly null," and the mere touching of the button may record everything which it has to give us. But generally features are less regular; a faultless

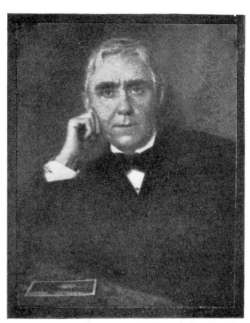

By Gertrude Kasebier, 1897
"PORTRAIT OF MR. B."

detail may be balanced by one less perfect, or the features may all be open to criticism, and yet the whole face charming by reason of its expression. Indeed, we shall admit that play of expression and mobility of features are in most cases the chief charm, while the rendering of these qualities is the most difficult thing in photography. For the source of the charm is its spontaneousness, which in presence of the camera is apt to disappear, the features stiffening. You wish to look your best and succeed in looking your worst, or even like nothing that your friends will recognize. But this expres-

sion is itself a radiation from the mind and character within. In the case of a little child, for example, over whose face there is a continual ripple of animation, it is the result of a nimble and sunny temperament. If the photographer can catch the child unconscious, he will probably catch the sunshine. But as the character develops in youth, doubt and hope and wonder and a hundred dim surmises ruffle the surface; the face laughs this moment, is pensive the next; neither is the whole character, only a suggestion of both will suffice. In later life character becomes more fixed, but often no less complicated. Shall we be satisfied with a rendering of features that does not mirror something of this inner personality?

You may think the question involves its own answer; but unfortunately it does not do so in the case of everybody. I could name a portrait painter, a fashionable one, which means he has an extensive clientage, of whom it is said that he always secures a good likeness. It may be so as far as the features are concerned, but if you do not know the ladies or gentlemen depicted the portraits will mean nothing to you. You are quite prepared to find eyes, nose and mouth represented, but in their arrangement you look in vain for individuality of expression, something that will identify itself in your imagination with a separate character, that, as you study the picture, will cause you to feel you are making the acquaintance of an actual personality. On the other hand, the great portraits of the world, which have survived the judgment of time, and are agreed to be great by succeeding generations of cultivated persons, owe their eminence partly, it is true, to their technical excellence, but a great deal more to the undebatable, perennially certain fact that they represent

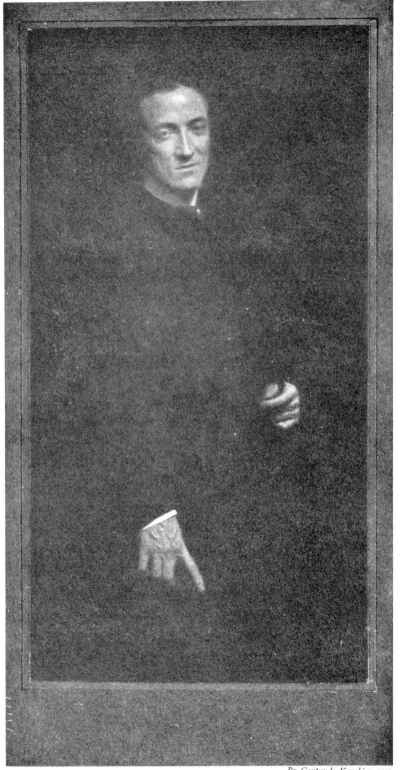

By Gertrude Kasebier, 1900

"MR. A. M."

human beings with such insight into character and fulness of expression that, although centuries may have elapsed, and our modern ideas of life be entirely different on the surface, those portraits have a fundamental relation to a common humanity. Their painters secured a vivid realization of character, the vital facts which constitute a separate human identity, and we look into their faces as into those of our acquaintances and friends.

Unlike the photographer in active work, the painter can reach his results gradually, having the advantage of many sittings, during which he is learning more and more of the sitter's characteristics. He can scrape his canvas clean and begin again, gradually through mistakes reaching the result which seems to justify him in laying down the brush and saying the portrait is finished. In fact, he is not dependent upon the sitter's appearance or condition of mind at any one moment, or upon his own momentary ability to compass the problem. The photographer is dependent upon both. Such limitations call for very exceptional powers, and explain why so few photographs are really good portraits. The photographer must have not only insight into character, but its keenness perpetually sharpened to a point; he must have the sympathetic faculty to gain the confidence of his subject, and the same continually, as it were, on tap. But people whose analytical and sympathetic faculties are most alert are just the ones whose temperaments are most susceptible. The least little thing may disturb their equilibrium; the chance remark of a sitter as she enters the studio, some detail of her dress or manner may stir an involuntary antagonism, which has to be gulped down and forcibly put out of memory before the work can proceed.

PHOTOGRAPHY AS A FINE ART

Again, even among people who realize what a portrait should be, there is much misconception as to what constitutes a good photograph portrait. The most common is that it should be clear and distinct, full of definition, the features clearly rendered, the dress—ah, how important a consideration!—distinctly recorded. Yet if people would study each other across the space of an ordinary sitting-room, they would discover how little definition they, respectively, present. They become patches of color against the colors of the walls and furniture; they are animated, individual personalities, and yet the outlines of their figures are not rigidly carved, but merge with the surroundings, and are softened by atmosphere. Still, how charming they all look, so spontaneously alive and interesting, and how their gowns become them! If they would pursue the study further they would find how large a part the distribution of light and shade plays in the attractiveness of the scene. The figures are not lighted from all the points of the compass in a stark glare, like the people on the stage. The real scene is a maze of shadows as well as light, moving with the movements of the figures, giving a hundred different sugges-

By Gertrude Kasebier, 1901
"STUDY OF A BOY"

tions of piquancy, dignity, subtlety, and so on. Perhaps no one will deny this, and yet he or she will ignore the logical conclusion, and visit the average photographer, who turns on the full light, producing a bald, hard, uniformly-lighted picture, unsuggestive, merely obvious, and too often commonplace. Whereas the photographic artist, by skilful adjustment of light and shade, will reproduce the accidental effects that, I hope, we are willing by this time to concede form so much of the charm in real life. He will go further and make them contribute to the expression of the most refined and persuasive qualities of the sitter's character.

Again, we may have noticed how the charm of a lady's presence is enhanced by her costume happening to harmonize with the colorings of the room. This is, again, an accidental effect, which the artist uses with intention; placing the figure in surroundings which will add to its dignity, individuality or graciousness, choosing colors which will merge into a prevailing tone; or, if he is a photographer, so arranging his darks and lights and varying their intensity as equally to produce a fine gradation of tone from the deepest dark to the brightest light. And, again, in the texture of the material of a costume there is charm. We need scarcely to be reminded how different is the sheen of satin from the soft, moss-like surface of velvet; how exquisite often is the union of white lace with the white hair of an old lady, what a different charm if the lace is black, and so on through all the textures, whether hard or soft, brilliant or dull. Each has its peculiar attractiveness, and a clever woman knows exactly by which her special characteristics are most helped. But have you considered how the beauty of the

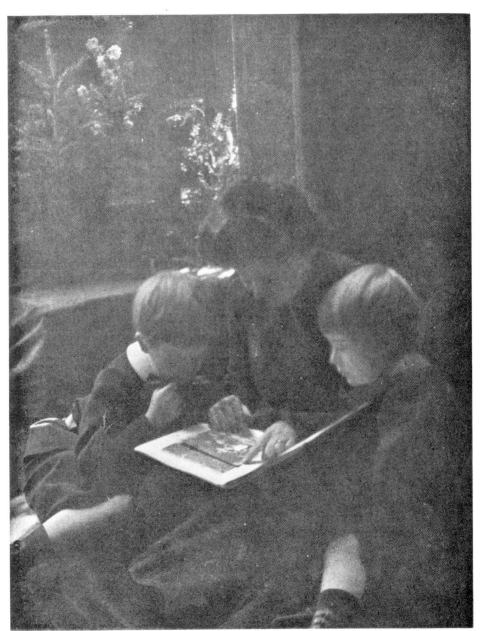

By Gertrude Kasebier, 1901

"FAIRY TALES"

texture depends upon the amount of light upon it and the way in which it reflects it? How hard and relentless, for example, a satin dress is apt to look in full daylight, while it has a subtle charm by artificial light, because the latter is distributed piecemeal with attendant shadow, instead of being all-pervasive. Yet the average photographer, or his client, ignores this fact, and the lady's form, set in full light, seems sheathed in metal. In the same way the lace fichu is made to look like perforated cardboard, the velvet like solid wood.

But why dwell so fully on these points? Simply because each and every one of them has its share in contributing to the beauty of the portrait, and they are precisely the points which are ignored, alike by the public and the average photographer, but are duly considered by Mrs. Käsebier. So, at the risk of giving much of the play without the appearance of Hamlet, I have dwelt upon these points, because they are essential to a comprehension and appreciation of this lady's work. Her portraits have character and individuality; for uniformity of definition and lighting she substitutes the suggestiveness of light and shade; not merely posing her figures, she composes them with the surroundings, and makes the whole composition a beautiful pattern of line and form and color, contriving at the same time that this pattern shall help to elucidate the character. Perhaps by this time we may detect a gentle cynicism in her avowal that she is a commercial photographer. It implies that, while she is making portraits for a livelihood as well as practising an art she loves, the exigencies of the profession sometimes interfere with the realization of her ideals; not always because time and opportunity are lacking for

"DICKEY"

By Gertrude Kasebier, 1900

mature study, but because, occasionally, the sitter is not of one mind with herself as to the ends in view, urging, or at least desiring, some compromise with the common-place. And you cannot conform to the average and be above the average at the same time, so the unreasonable insistence must involve certain tuggings at the artist's heartstrings, justifying a little cynicism.

Whether by chance or design, the majority of illustrations to this article are studies of children. Nearly all of us love a child, but not all in the same way. Some are so enamored of the child being the promise of the man, that they would have him a manikin in petticoats or short pants; finding amusement even in that odious form of cuteness known as "smart." Others will load with finery the little limbs that Nature has meant for free action and due acquaintance with healthy dirt. These are not the sort of children in whom Mrs. Käsebier takes much interest. Her children are essentially childlike, fresh little buds of vitality with the fragrance of unconsciousness. She woos them into her confidence, sets them to amusing themselves, or holds their interest, and catches them in their unsophisticated naturalness. I turn to her *Portrait of a Boy*, and find myself laughing. At him? By no means; he has too much skull beneath that soft thatch of hair, too much possibility of character in those chubbily decisive features and wide-apart, honest eyes to give any cause for ridicule. But the sturdy little face is so deliciously childlike, so unconscious of anything but the something which is making his brain ponder, while he sucks in his under lip in a sort of a poise of judgment, as to what the strange lady is trying to do to him, that I laugh, as I have laughed on the top of a

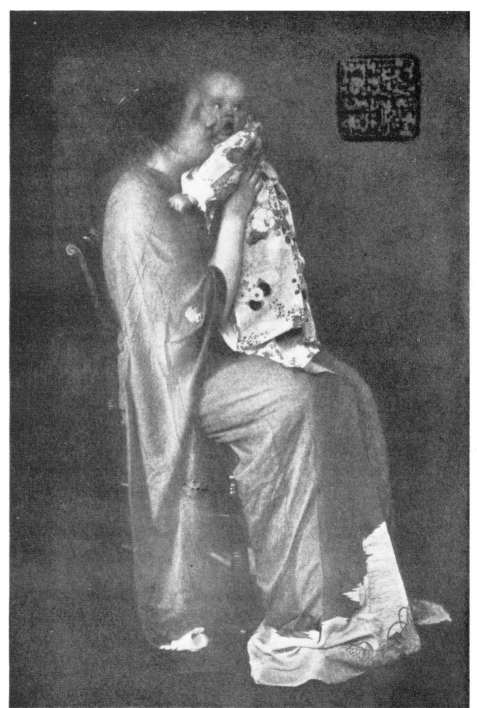

By Gertrude Kasebier, 1900

"A GROUP"

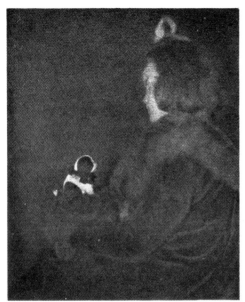

By Gertrude Kasebier, 1900

"MISS SEARS"

mountain, in sheer exuberance of spirit, filled with the sense of abounding wholesomeness. Do you mark the extraordinary realism of the soft, smooth hair and the podgy inequalities of the features? Let us imagine, for a moment, the face, as it would ordinarily be photographed, white and smooth, with only enough shade to indicate the modeling of the features, the background whitish, and the costume defined as if to advertise a tailor's stock. Would the picture have had the distinction of this one, viewed only as an effect of color, of tonal arrangement? Would the head have had the naturalness and character of this one? Far more, would there have been the mystery and the poetry of this child-face peering out of the depth of shadow, as it were, into the obscurity of his own future? Perhaps we recollect how the old Saxon likened the life of a man to the flight of a bird through the dimly-lighted hall—" out of the darkness into the darkness." Some such depth and poetry of feeling is in this little portrait.

Now turn to her *Going to Boston*, on page 55. Surely, I may enjoy my healthy laugh again, if only at the plaintive insipidity of the stuffed lamb and the lovely

inventiveness of the artist, who dares to be playful and at the same time can produce a picture so truly beautiful as this. I turn it upside down and this way or that, and every way it is beautiful. Its adjustment of the forms to the space, the subtlety of mass and line and balance of the dark and light seem equally admirable. How wonderful that quivering thrill of light which appears and vanishes in the line of the string! The picture has the decorative simplicity and exquisite precision of a fine Japanese print, and the feeling expressed by purely æsthetic qualities is echoed in the characterization. This youngster was evidently a person of action with a predilection for the strenuous life. He would be in his element climbing trees, but for the moment must be held in repose without loss of active suggestion. His father

has lately taken a journey, the son shall do the same. A valise big enough to hold himself is ready to his left hand, his right one holds his overcoat. He is prepared for a start, and meanwhile the lamb stands there in evidence that he is only playing, after all; and in order that the fun may not be at the child's expense, the lamb is prominently in the light, and the boy's

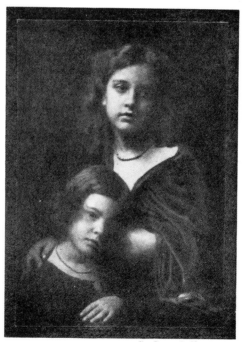

By Gertrude Kasebier, 1900
" PORTRAIT "

own dear little face in serious shadow. Comparing this picture with the previous one, can we refuse to admit that in an artist's hand shadow as well as light will bring out character in the face?

Can anything be more childlike and unconscious than the expression in the face of *Dickey*, and the gesture of the hands? Yet with all this artlessness, how artful is the introduction of the flowers, the soft, silk fichu crossed low over the neck, and the stiff little bow, which last adds a quaint spot of emphasis, thus drawing the eye and insuring that the head shall be the first and last part on which the attention rests. The picture represents a charming little conceit of fancy, which detracts nothing from its serious sweetness.

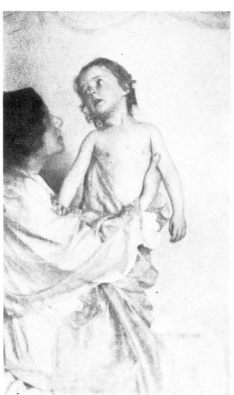

By Gertrude Kasebier, 1897

"MOTHER AND CHILD"

The group called *Fairy Tales*, of a lady and two little boys bending over an album, involves a more complicated problem of composition, lighting and characterization. I wish that my readers could see the original of this, printed in brown, with such a rich range of tone and varying quality of color: opaque in the background on

the right and having a wooly, cloth-like texture; soft, transparent on the children's hair, smooth and lambent on the flesh, and smooth, but crisper on the cloth suits. What complete unanimity of interest in the attitude of the three heads, and yet difference of feeling! One boy, for example, attracted lightly by the picture, the other giving his mind to it, with hand lifted unconsciously to the chin in concentrated attention. I can understand some one objecting that the boy's face is so much in shadow that the features are almost indistinguishable. One may share the regret and yet feel that this loss is compensated by a greater gain in the shrewd revelation of the boy's character. This indication of quiet, penetrating earnestness should be a more precious document for a mother to cherish than one merely of the features, both because it is a much more

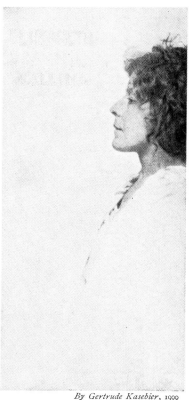

By Gertrude Kasebier, 1900

"PORTRAIT"

difficult thing to have attained, and because it dips into the unplumbed mystery of the child's mind. The qualities of his brother's mind, on the other hand, one may judge to be of a more obvious kind, so there is a spiritual suggestion in the contrast of light and dark in the two faces.

PHOTOGRAPHY AS A FINE ART

A similar quality of spirituality reappears in the *Portrait*, on page 69. What beauty of character and temperament is suggested in the older girl! the effect being assisted not only by the suave dignity of the pattern of light and dark, but by the exquisite pose of the figure, the lean of the head, lift of shoulder, and the expression

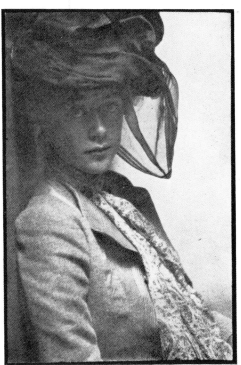

By Gertrude Kasebier, 1900
" MISS D. "

of the hand which rests upon the younger child. The latter nestles very naturally, but the deep shadow on one side of her face is unfortunate, detracting from the roundness and softness. But even so, the picture is most beautiful, having the rich quality, both in tone and spacing, of an old Venetian master.

A quality shared by all the prints we have been discussing is sincerity. I do not mean of purpose and workmanship, which go without saying in this lady's work, but of method. To express the character and make a beautiful picture the means employed have been those of sound and serious art, without any trace of affectation or trick to secure distinction. Of the former, some might see a suspicion in the portrait of *Dickey*, on page 65, but I refuse to perceive it, for the face, quaint

By Gertrude Kasebier. 1896

"CORNELIA"

and dreamy, justifies the treatment. The slight bizarrerie of *Miss Sears* may also be justifiable. The child would seem to be a demure, prim little miss, rather mannered for her age; her hair is dressed in a very formal way, the handsome coat is in style much as her mother might wear, and as she sits with the stuffed dog on her lap and the queer

bow on her head, she has the complete self-possession and some of the complacency of an adult. She is not playing a little game like the small boy with the lamb; she seems conscious of posing for a cunning effect. Hence the feeling of the picture does not ring true; it is forced, unspontaneous, and the promi-

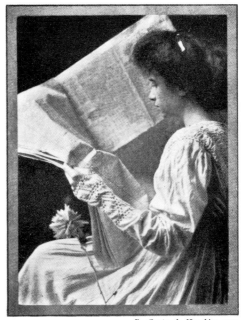

By Gertrude Kasebier, 1900

"LADY WITH NEWSPAPER"

"LA GRAND-MÈRE"

By Gertrude Kasebier, 1894

nence given to the dog seems freakish, the bow tiresome. Still I should judge it a very telling piece of character rendering.

It needs boldness to suggest that there is affectation in the beautiful *Group* on page 67, for nothing could be more simple and heartfelt than the management of the mother's and baby's heads and the expression in each. But why the Japanese costume? Why not? may be the retort. Because this lady is not Japanese, or she would not be sitting on a chair, but kneeling on the floor with her body on her heels in a cosy mass of drapery; and this device of dressing up a subject to make a pretty picture is one of the ordinary resources of the photographer who has not the knowledge of art possessed by Mrs. Käsebier, and is accordingly driven to such shifts in trying to make his picture distinguished. It is my respect and admiration for this lady's art that make me judge it only by the highest standard. For this reason I cannot cordially accept the *Decorative Panel*. The child is so obviously put on view. The old-fashioned photographer would have put a piece of figured drapery over an armchair, and hidden the mother behind it to hold the baby in position. This is not so bald a device, but here we have instead of a draped chair a draped mother with her head bowed in shadow. Of course we know why; but if the attitude and treatment of shadow have any æsthetic meaning, they indicate profound grief, which is not justified by the possession of so healthy and well-formed a child. Again, one of the main beauties of a child's limbs is their satin texture. So we miss in this picture the full quality of loveliness in the child's figure, and the artistic charm of spontaneousness and unity of feeling in

the whole conception. It is a set-piece rather than a glimpse of nature. So most explicitly is *La Grand-mere*, which, however, it should be noted, was executed some years ago. The scene is a rude one with mixture of sun and shadow, suggestive of the life of the poor; the old woman is a sturdy, wholesome type, who has done her simple duty, upheld and cheered by religious faith. Surely an artist could have led our imagination to this point without the crude device of making her hold a crucifix to her breast. No; she has been posed, and one resents the artificiality as an imposition. There is more than a little affectation also in the profile *Portrait* on page 71, for the self-consciousness of the face interferes with the spontaneity which such a treatment demanded. Yet the artistry of this print, apart from its sentiment, is exquisite. I have the original before me, and the beautiful quality of color in the head, the contrast between the soft confusion of the hair and comparative flatness of the face, the dainty touches of definition in certain of the features, and the suggestive line that passes down the figure, appearing, reappearing, delicately emphasized in parts and fading away into the paper imperceptibly, so that one cannot tell where it ceases—all these exhibit a sensitiveness of artistic feeling and handling beyond praise. If I may try to paraphrase the impression with which it affects me, I would say it is like a deep, full breath, passing away in a sigh; a suggestion so exquisitely subtle that I wish the breath had been the expression of a more sincere, less self-conscious feeling. Quite possibly this fancied detection of insincerity may be due to some prejudice of my own. One can only state one's opinion honestly, giving at the same time one's reasons, so that

"ADÈLE"

By Gertrude Kasebier, 1898

the reader may judge whether the conclusion be good or bad.

What shall we say of *Mother and Child?* Beautiful it certainly is, if only for the delicacy of light and shade in the folds of the lady's white gown. It seems to have been the result of a sudden impulse of enthusiasm. One may imagine the general conception of the picture settled and the artist waiting for her opportunity. The baby suddenly glides into a pose with head thrown back and eyes raised. It is like an infant Christ or wingless cherub. Exquisite! Even the mother shares the excitement of the moment, as one may see from the tense action of the head and fixity of the gaze. The picture is taken and is very spiritual and beautiful, yet the pose and expression of the child have not the unaffectedness of a baby. The result is, baby plus the enthusiasm of the artist for something she did not expect to get, and could only have got by accident; certainly not normal, simple, characteristically childlike.

A mastery of subtle effects of light and shade is seen in the picture of a *Lady with Newspaper*, in which the open sheets are made to yield a most interesting pattern of form and color, while the mingling of light and dark in the folds of the dress is full of poetic suggestion. In the *Study of a Boy* the difficulty of setting the camera at the window has been triumphantly overcome. The massing of shade upon the left is full and deep in tone, in the original especially a joy to study, and the pensive expression of the young man's face, so admirably unaffected, has a delightful reference to the misty distance of view outside the window. It is a surprising and most impressive picture; strong, deep and subtle. Of the print,

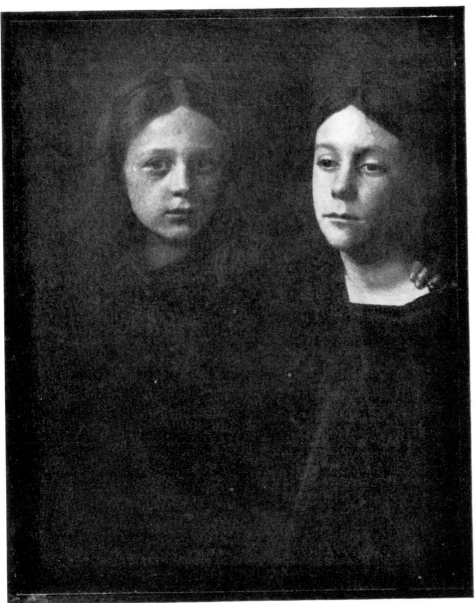

"SISTERS" *By Gertrude Kasebier, 1901*

Mr. A. M., on page 59, I have only the proof before me, so that I cannot speak with such extended admiration as I am sure the picture warrants; for even in this rough state the treatment of the head, and the two hands so strangely echoing its expression, and the placing of these three spots against the plunge of dark, are managed with a comprehension and fulness of artistic feeling most delightful. The beauty of the picture *Miss D.* needs no commending. Its appeal is instantaneous and enduring. Only I would dwell upon the consummate feeling and skill with which the character as well as the features are made to emerge from the soft shadow. It is as fine a refutation as could be of the ordinary fallacy that the face should be brightly lighted and defined.

To sum up one's impressions of Mrs. Käsebier's work, as illustrated in these portraits, it is, in the first place, sympathetic, influenced by love and enthusiasm as well as knowledge. She has a keen intuition of character, and a wonderfully swift inventiveness of means to express it, for we may conclude that certainly the majority of these pictures have been done under the ordinary conditions of fulfilling appointments. Each has an unexpectedness of treatment, presupposing a mind stored with artistic resources and an imagination alert and fertile. Equally spontaneous is her sympathy. She has a remarkable power of focussing her interest upon her subject and of discovering the best qualities. The means by which she gives expression to her conceptions are those of a thorough artist, and in almost every case of a "straight" photographer. Indeed, the *Portrait*, page 71, is, perhaps, the only example of a picture conspicuously altered in the process, and here it is mainly in the way of elimination.

Her resources are the management of line and form, and of light. These she handles, not merely with knowledge, but with a vivid imagination and poetic instinct; securing, as she needs it, dignity or delicacy of line and mass and fulness or evanescent charm of color. The quality of the latter can only be guessed from the illustrations, but many of the originals urge one to use that much-abused term " orchestration of color." No other seems so fitting; for example, her dark passages have a resonant, sonorous quality; elsewhere the effects of light are flute-like in their tremulous purity, or the impression upon one may be of the vibration of stringed instruments, and all are fused into a harmony of tone and feeling.

CHAPTER IV.

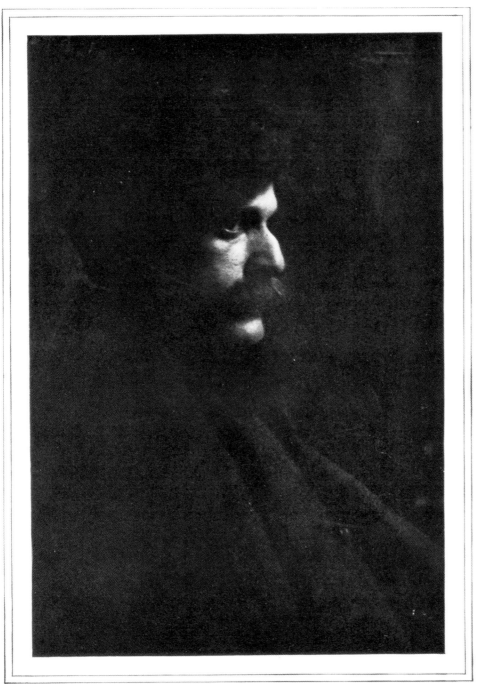

PORTRAIT OF ALFRED STIEGLITZ *By Frank Eugene,* 1900

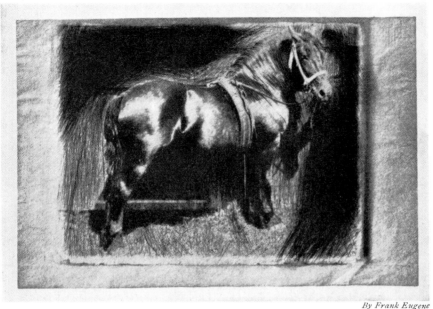

"THE HORSE." SHOWING A BOLD USE OF ETCHING IN THE BACKGROUND

CHAPTER IV

METHODS OF INDIVIDUAL EXPRESSION

ILLUSTRATED BY THE WORK OF FRANK EUGENE AND JOSEPH T. KEILEY

IT is not because the work of these gentlemen offers any special point of resemblance that their names are coupled; nor do I propose to institute any comparison. But they have in common an identity of motive, which, however, is shared by innumerable others, so that it is as the type of a class, and as illustrating an important phase of photography, that they are to be considered here. They represent, at any rate, in a great deal of their work, the opposite to the "straight photograph." They largely "manipulate" their negatives or prints to secure the desired result.

PHOTOGRAPHY AS A FINE ART

The goal of the best photographers, as of all true artists, is not merely to make a picture, but to record in their print and transmit to others the impression which they experience in the presence of the subject. This sounds like " Impressionism," and indeed it is, in the broadest meaning of that term, which, however, in common usage has been whittled down to a narrow significance, to particularize that group of artists whose fondness for painting light would better justify the distinguishing name of " luminarists." In a broad sense all artists are impressionists. They do not picture the object itself, but what they are conscious of seeing. One man may be satisfied to represent merely the external facts of the object; but if nine other men, facing the same object, set about doing the same thing, the ten would not produce identical results. In each case it would be tinged by the individual's particular way of seeing. The thing pictured would not be the object, but a record of the impression made by it on each of the separate pairs of eyes; every one of the ten would be involuntarily an impressionist.

Another man, however, will be conscious of the impression made upon his mind; and it will seize upon his imagination, and thus become itself colored by his personality. If, then, he tries to picture this impression, using the object, not as an end in itself but as contributory to his impression, omitting some details and emphasizing those most important to his purpose, he is an impressionist in the sense in which we are using the term here. I cannot better signify the difference between the painter or photographer who is satisfied to be a recorder only of the external facts of the object, and him who forms a vivid mental conception of it and tries to make us realize his

impression, than by comparing the street arabs of J. G. Brown with Murillo's. The former are, as it were, word for word translations into paint of the shoeblack or newspaper-boy—snatched, too, from their context of busy city life and rendered in isolated fragments; nor, it may be added, with much characterization of the dirt and super-sharpened wit of the originals. Murillo, on the other hand, saw his boys as part of the lazy, sunny, shiftless life of the Spanish street—attracted, no doubt, as a painter by the artless freedom of their gestures; and he painted them with the dusty sunshine on their healthy burnished limbs, and with the dirt encrusted on the soles of their feet, which, you remember, so troubled Ruskin. But Murillo in his

By Joseph T. Keiley

PORTRAIT OF ZOLNAY, THE SCULPTOR

sympathy with boy-life had no horror of dirt, no doubt seeing in it the reason why those limbs were so lithe and sinewy; the boys running wild like young creatures of the forest and basking in the sunshine, as near to nature as the denizen of a city can get.

Or, again, to emphasize this point, let me compare Abbey's illustrations of Goldsmith's *She Stoops to Conquer*

with those he made for Shakespeare's comedies. In the former a trivial interest in what the characters are represented as doing is swallowed up in the larger enjoyment of the wonderful way in which the artist has recreated the atmosphere and sentiment of the old times. He made them in the little village of Broadway, in England, where the mind, as those who have lived there know, can readily detach itself from what is modern and drift naturally and easily into the old feeling. Enough of it still survives to whet the imagination and help it to conjure up vivid impressions of the past. But when he came to illustrate the comedies of Shakespeare, he found no such spontaneous inspiration, and had recourse to archæological research; the illustrations are satisfactorily correct, but impressionless. On the other hand, when Elihu Vedder undertook the illustrating of Omar Khayyám, he did not picture literally the phraseology of the text, but absorbed its spirit, and, having taken the beauty and meaning into his own soul, gave out of himself a painter's equivalent for the thought and imagery of the poet. So his work stands as an interpretation or, better still, a reincarnation. The old Persian's thought has transmigrated into a new state.

Even to any one who has not thought of these things before, one may hope that there is a dawning consciousness that the conceiving and imparting an impression is more to be desired than a bald statement of fact, such as would be obvious to any one; just as we hang upon the speech of an orator, less for the facts he formulates than for the new significance they acquire after being fused in the crucible of his own vigorous personality. If, therefore, I have been so fortunate as to carry my reader with me, we have reached the conclusion that the chief beauty

in a work of art, be it painting, photograph, or silver salt-cellar, is the evidence of the artist's expression of himself. It is manifested diversely. In a portrait, as we said in the last chapter, it shows itself in ability to sympathize with the subject, to penetrate behind the mask of the features, and to present an epitome of character as well as of appearance. Again, in ever so simple a picture of domestic life, a *genre* subject, there will be given not only the facts of the episode and its local surroundings, but also the essence of the matter, the sentiment; not expressly stated, but to be felt. I remember a very happy example in the Danish Section at the recent Paris Exposition in a picture by Irminger, called *Past Midnight*. A young husband is studying or writing, and the wife has slipped down in her night-robe and stands behind his chair. The story is trivial enough, but I would draw attention to the artist's way of telling it. In the choice of details, simple and refined: the soft, diffused light from the shaded lamp, glinting tenderly on the flowers, leather backs of books, and the young man's earnest face mostly in shadow, and shed so reticently over the white-clad figure of the girl-wife; the lovableness of a happy home, the beauty of absolute accord, are suggested with an amount of imagination that lifts a trifling circumstance into a poem. Or, again, the photographer or painter may render a landscape that we recognize as true to nature, but which affects us as little as the glimpses that flash before the eye as we speed along the railroad. The fault may be in ourselves or in the painter's inability to conceive and transmit a vivid impression.

A love of nature is one of the things that you cannot buy at a department store, nor may it be acquired from

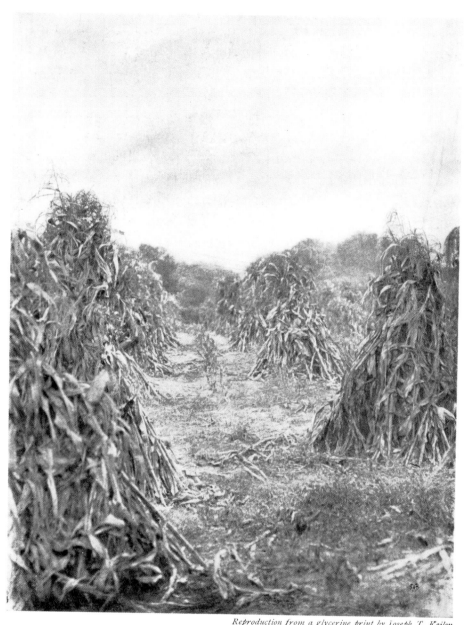

"CORNFIELD VISTA" IN AFTERGLOW OF AN AUTUMNAL SUNSET

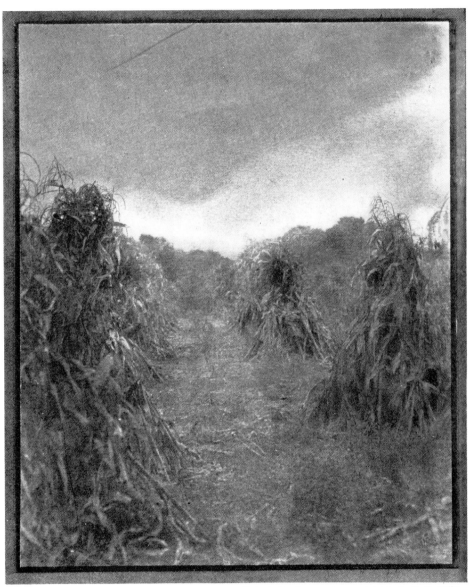

Reproduction from a glycerine print by Joseph T. Keiley

"AUTUMN TWILIGHT"

This scene is identical with "Cornfield Vista," reproduced on page 91, but the character has been altered through local development of the print

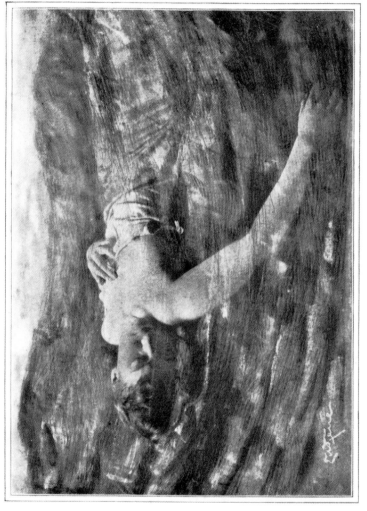

"NIRVANA"

Reproduction from a glycerine print by Frank Eugene

An interesting experiment. By the use of the brush and needle the sofa upon which the model reclined has been converted into water

text-books. It must have origin and growth in ourselves. But if I am speaking to a lover of nature, he knows better than I can say that his joy in it is the result of communing, companionship, and intimacy with nature. That clump of trees upon the rising ground has a vigor of outline that long ago arrested his attention, but he has become so used to its features that he takes them for granted, as we do the face of a friend. Meanwhile, what interests him is their ever-changing play of expression. At dawn, noonday, or twilight, under gray light or burning sunshine, when storm is gathering or everything is at peace, in countless other vicissitudes of local conditions, those trees, lifted up against the sky, take on moods and changes of expression, making constant variety of appeal to his imagination, and always somehow fitting in with his own mood of feeling. In our ability to put ourselves thus at one with nature we ourselves are artists—unable, however, to give utterance to the thought. The creative power is lacking, and this is the distinguishing characteristic of the artist. He is the creator; and, the more we realize this, the greater our delight in art which involves a personal expression, and the less interest we feel in the process which merely records facts.

In the early stages of photography man's interest was captured by the camera's ability to record facts; today, the artist's aim is to make it record his impressions of the fact, and to express in the print his personal feeling. The camera's ability was overrated. Because it can take in so much more detail than the human eye, its accuracy of vision was regarded as infallible; whereas, in effect, it is less accurate than the trained eye, falsifying the record by undue enlargement of the objects near, and diminution of

those more remote. So the artist in his search after truth has set himself, first of all, to correct the camera's failings; not, however, in the generally accepted way, as, for example, by eliminating every inequality in the features of a portrait and reducing them to the simpering smoothness of a milliner's wax model. This is the commonplace method, aided and abetted by the vanity of the sitter. I have heard it stated, in connection with a portrait, that the artist would have done well to soften down the prominence of the bones in the lady's neck. For my own part, I think the lady would have done better to cover up her bony neck. The prominence of these bones has a physiological relation to her character, and for the artist to have clothed them with firm, soft flesh would have been to contradict the expression of the face. But this is dangerous ground! Let us leave it for the safer one of landscape. Suppose the vista to be photographed is a mile in length, every yard of it gradually receding from the foreground. If the camera jumps the middle distance, and extends the horizon in appearance to two miles away, the whole character of the scene is falsified. The photographer in the printing seeks to correct this deviation from the truth. This is his first argument in favor of manipulating the print; and some photographers have another. "That scene," says one, "excites a certain impression in my imagination, the result partly of association, partly of my individual temperament. I want to express that phase of the scene and communicate it to you. The unresponsive eye of the camera will not see what I am striving for, but I will try to extract from its record, or infuse into it, my motive." So he manipulates his print. Another with the same end in view will manipu-

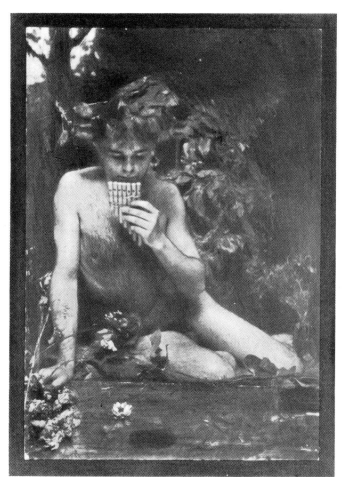

"SONG OF THE LILY" *By Frank Eugene*

late the negative. Mr. Eugene, for example, will draw or paint or etch upon the negative. There are many methods of controlling the development of the print, but we will confine our notice here to the glycerine process of developing platinum prints, because it is the one which Mr. Keiley always uses, and which in conjunction with Mr. Stieglitz he has brought into extended usefulness.

Briefly, the process is as follows : a print is made from the negative upon platinum paper in the usual way ; unlike silver printing, in which the image prints out by the action of light, the image on the platinum paper is very faint, needing a further process of developing, and it is at this point that the photographer controls his results by means of glycerine. The print is coated with it, and the effect of this is to retard the action of the developing solution which, either pure or mixed with glycerine, is then applied with a brush. The pure developer brings out the platinum black, or, when diluted with glycerine, the lighter tones, while in the parts to which the pure glycerine is applied no development ensues. So the operator, by merely spreading the glycerine, can elim-

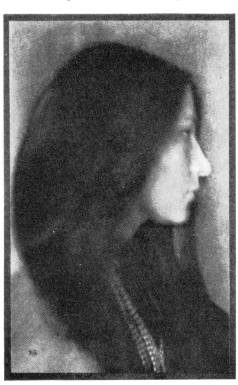

By Joseph T. Keiley

"AN INDIAN MADONNA"

inate what he pleases from the print, and convert light parts into dark, or *vice versa*. The advantages of this process are summed up in a brochure, entitled " The ' Camera Notes ' Improved Process for the Development of Platinum Prints, Including the Experiments of Joseph T. Keiley and Alfred Stieglitz." " The great merit of this method of development"— the words are Mr.

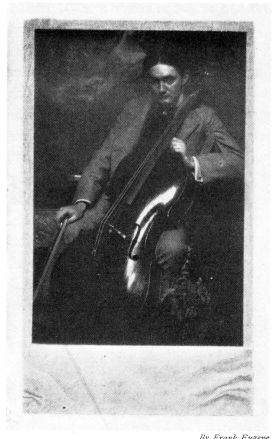

By Frank Eugene

"YOUNG MAN WITH 'CELLO"

Keiley's—" lies (*a*) in its corrective possibilities, and that through it the manipulator is enabled to reclaim the print from the rigid bondage of the hitherto unalterable renderings of values recorded therein during the process of printing, and (*b*) to introduce into it his own conception of the values, tonal qualities, feeling and artistic effect of the theme under treatment."

I have taken the liberty of dividing the quotation into two statements, because they seem to contain the gist of the difference between its use by the straight photog-

rapher and the other one—I cannot call him "crooked"
—who claims unrestricted liberty of action. The former
only *modifies* the result; the latter reserves the right to
alter it. The straight photographer may feel a shadow to
be too dense, so he reduces it in the printing; or the fore-
ground too full of detail, and confuses it to bring it to a
mass, or he will retard the printing of the stronger parts
while he coaxes up the delicate tones in the sky, and so
on. But the result is substantially nature's image. On
the other hand, a reference to the two parallel examples
of a cornfield by Mr. Keiley, reproduced on pages 92 and
93, will show how completely in the second one the
character of the scene has been altered in the printing.
Or, again, as an instance of manipulating the negative,
note the *Nirvana* by Mr. Eugene. The model was posed
upon a sofa, but this has been obliterated and water sub-
stituted by the use of the brush and needle. We could
not have more suggestive examples of departure from
nature than these; the latter a subject built up to express
an ideal conception, and the former a twisting of nature
into the groove of the artist's own impression.

Immediately two reflections occur. Firstly, such
alteration of the negative's version demands the skill of
the draughtsman or painter; in the hands of any one
without training in art it will lead to deplorable results.
But this need not be dwelt upon, since it involves no fur-
ther statement than the fact that a man should not try to
drive an automobile on a crowded street until he has
learnt how, and the best way of learning is to study the
theory and then put it in practice. But the second reflec-
tion does involve a serious consideration. If nature is the
source of beauty (and few of us will question it, particu-

larly in the case of landscapes), can we derive as much pleasure from an interpretation of nature evolved out of a man's brain, however poetical, as from one studied from nature direct? Perhaps we may; but not, I think, if we

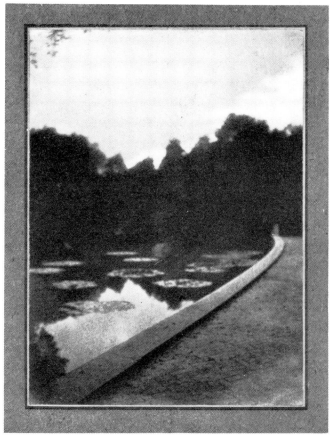

Reproduction from a glycerine print by Joseph T. Keiley
"GARDEN OF DREAMS"

ourselves are nature-students. You may have observed in a collection of painted landscapes how some have the real open-air feeling, bringing to your imagination the fragrance and tonic of the breeze, the joyousness of sunshine, or the mystery of twilight; while others, beautiful

in their way, appear to be simply pictures. On the other hand, I do not forget that there is room for pictures of the imagination as for poems or music drawn from the artist's inner consciousness; and if the painter's or photographer's imagination is full and powerful, he may give us pictures of great beauty. But such imaginations are few and far between, and for the majority it is safer to be students of nature than weavers of their own fancy.

A fair conclusion seems to be that while these landscapes of the imagination may be handsome pictures and emotional, they will lack the subtlety and infiniteness of nature's truth—representing the impression in a broad, discursive manner. The reproduction of Mr. Keiley's *Garden of Dreams* illustrates this. It is wrapt in a solemn pensiveness, as if the tread of Time were hushed, and nature were wooing to gentle contemplation. But I find no mystery in the scene or range for my imagination. The wall of trees is impenetrable, and does not lure the fancy on to lose itself in shadow; the lily-pads, floating on the smooth water, are lighted almost uniformly, those beneath the shadow as well as those in light; there are not the delicate differences of tone that would make the scene vibrate. The stillness, in fact, is rather of death than of sleep. Again, in the *Autumn Twilight* evolved from the *Cornfield Vista*, I find variety of tone in the light and dark upon the shocks, but neither the impressive intelligibility of massed lights and shadows nor the delicious surprises of effect that the waning light, lapping the shocks and stealing between the leaves, would give in nature. Nor is the black mass in the sky convincing. It is not the darkening of the upper sky or gathering cloud on the horizon, for it has no construction; it seems rather

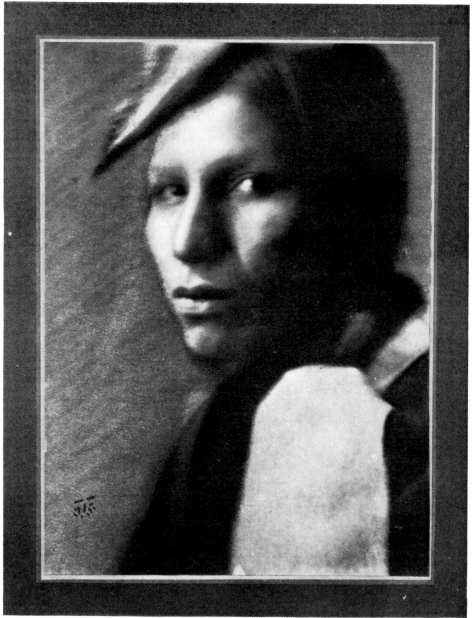

"A SIOUX CHIEF" *By Joseph T. Keiley*

"PORTRAIT OF A CHILD"

By Frank Eugene

The dress has been etched, apparently to make an effective contrast with the face

a shred of rainy mist carried by wind, which scarcely is in tune with the serenity of the scene. One finds it, in fact, a beautiful arrangement of dark and light, but from its lack of truth to nature very limited in the range of its impressiveness. The reader, I hope, is not tired of this harping upon nature; but, after all, we can be impressed only through our experience. A hundred thousand persons perishing from famine in India do not move me as deeply as the death of a friend's little child. I love the child and the parents, and realize the awful gap now made in their home and hearts. And so the artist to arouse our imagination had better rely upon something we know and love in common. He finds it in nature, and his work, if true, becomes a part of her inexhaustibleness, setting no limits to his possibility of suggestion and to our receptivity of impression. If he lets go of nature, he accepts his limitations and imposes them upon us.

Therefore out of these eight examples of Mr. Keiley's work many of us will prefer the figure subjects, particularly those of Indians. They show such an intimacy of understanding and fulness of sympathy that we scarcely need to be told their author was an interested student of Indian life before he made these portraits. The head of a young girl, very sweetly called *An Indian Madonna*, is inexpressibly moving, admitting us at once into the temple of a human mind. The outer court is beautiful, and the veil of mystery which hangs before the shrine not so dense but that we may peer through, guessing rather than seeing some vague hint of the mystery beyond. Who may penetrate the sacredness of a maiden's mind? And this is of an alien race—one fading from the earth, with memories and associations outside our own; she is of good

education, too, and a beautiful habit of mind—what a tanglement of mystery one meets in trying to fathom the depth of her thoughts. The artist here has set us on the threshold of infinitude; there are no bounds to the suggestiveness of his picture or to the workings of our own imagination.

Mr. Eugene is unwarrantably regarded as the very antipodes of the straight photographer. As a matter of fact, he never manipulates his print, and by no means always touches the negative. We have noted, however, his daring experiment in the *Nirvana*; and again in *The Horse*, reproduced at the head of this chapter, the background and straw have been fearlessly etched upon the negative, and brush and point as well would appear to have been used on the horse. The print, in fact, has the quality of texture and spontaneousness of a fine etching. On the other hand, the *Man in Armor* (a portrait of himself) has received no manipulation at any stage, and the same is true of the other portraits, with the exception of that of a child, in which the dress has been etched over, apparently to give it

By Joseph T. Keiley
"VINE-CROWNED." A SUMMER IDYL

transparency and to throw by contrast more substantialness into the face. The fact is, Mr. Eugene is not unreservedly addicted to any method. A painter

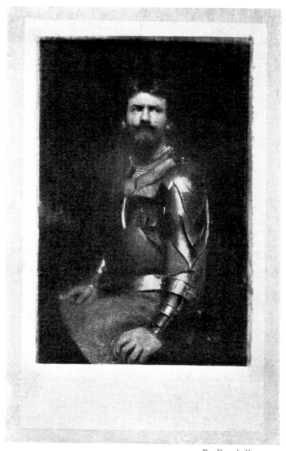

By Frank Eugene
"MAN IN ARMOR"
This portrait of himself received no manipulation by Mr. Eugene at any stage

first of all, he gradually became interested in photography, and finally enthusiastic, discovering that it had possibilities for him unobtainable by any other process. He is a man of extraordinary vigor and versatility, keen after artistic problems; and whether he uses the negative

straight or works it up or alters it entirely, is merely a question of expediency, the sole aim being to reach the result in view. In his portraits and subject pictures he often uses backgrounds of his own painting, combining with them real foliage. Such is the case in the *Portrait of a Child*, and, I suspect, in the *Song of the Lily*. And note the exuberance of his artistic invention, the robust wholesomeness of his work, his skill in large and handsome compositions, and feeling for rich, impressional color. The examples shown here, *Nirvana* excepted, which is only an interesting experiment, illustrate these qualities, though they suggest but little of his versatility. He will be represented at the Glasgow International Exhibition by an *Adam and Eve*—one of the most beautiful studies of the nude I have seen in any medium. The forms are noble, the dappling of light and shade as they stand in the garden exquisitely subtle; and while the beauty of flesh texture has been rendered admirably, the figures are treated with such artistic reticence that there is not a hint of nakedness.

I have spoken of the print of the cart-horse having the quality of an etching. This seems to have a bearing on the question sometimes asked of the photographer: If you desire the effect of an etching, of a chalk or wash-drawing, why not etch or draw with chalk or water-color; why use the camera and confuse the processes? Well, to myself, that print, printed as it is on Japan paper, conveys every impression of an etching, having the beautiful characteristics that one looks for therein: spontaneousness of execution, vigorous and pregnant suggestiveness, velvety color, and delightful evidence of the personal touch. There is nothing sacred or even desirable in the mere

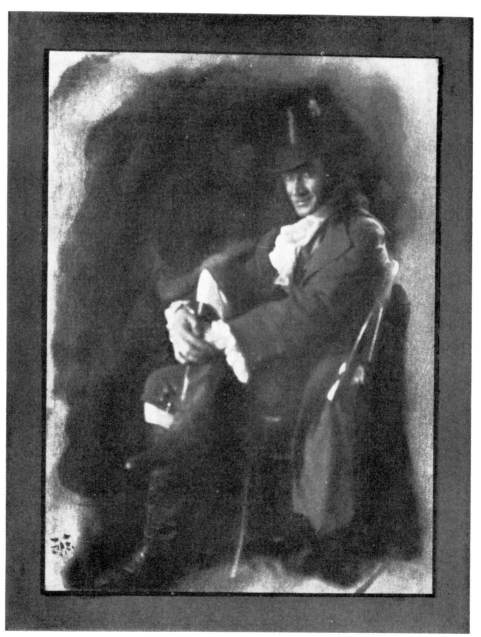

"CITIZEN FOUCHÉ" *By Joseph T. Keiley*

process of etching upon copper apart from its results. If similar results can be obtained some other way, and the artist chooses to adopt it because he finds it easier or more congenial, what concern is it of ours? Surely none. I may have thought and written otherwise in the past. Let me admit conversion. The fact is, in this new art critics and photographers alike are feeling their way—they to expression, we to judgment. The art is still in the womb of time, its possibilities continually becoming wider and more appreciated; being new, one learns that the old standards and points of view do not necessarily apply to it, and more and more realize the need of an open mind.

Meanwhile, as I have said, experience is the basis of our ability to appreciate: one can but speak as one knows, adding to that knowledge by degrees. So, in trying to enter into the question of manipulating the result, I have clung intentionally to the conservative standpoint, because in the eagerness of a new movement it may easily be overlooked; whereas, to alter slightly—or shall I say manipulate?—Gamaliel's advice to the Jewish critics of the new Gospel, "If it be of art ye cannot overthrow it; lest haply ye be found even to fight against art." And if I have said comparatively little concerning the individual work of these two artists, it is because I took them as a type, and believed that I could best arouse an interest in their work by dwelling upon the principles which it involves.

CHAPTER V.

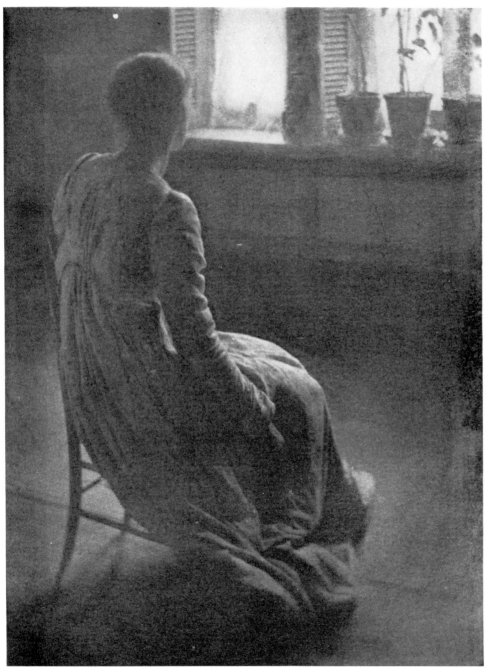

By *Clarence H. White*

"EVENING—INTERIOR"

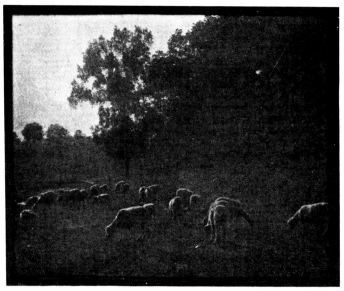

"LANDSCAPE WITH SHEEP" *By Clarence H. White*

CHAPTER V

OTHER METHODS OF INDIVIDUAL EXPRESSION

ILLUSTRATED BY THE WORK OF CLARENCE H. WHITE AND WILLIAM B. DYER

E are continuing in this chapter a study of the possibilities and means of personal expression in photography. Whether there are, indeed, possibilities represents the actual crux of the question: Is photography to be reckoned among the fine arts?

By those who have followed the course of this series, I venture to hope that the question has been answered in the affirmative. But ignorance or indifference on the subject is very widely spread. I am reminded as I write that the authorities of the Pan-American Exposition made no provision for photography in the art section; on the other hand, that those of the International Exhibition

at Glasgow not only did so, but sent over to this country a special commissioner to secure a good representation of American prints, and that these attracted much favorable comment in comparison with the British, French, German and Austrian work, simultaneously shown. Evidently the Scotchman has "a bee in his bonnet," or else on this particular point he is far ahead of the progressive American. Our authorities at Buffalo seem to have shared the common notion that photography is only a mechanical process; that a piece of glass, coated with a film of bromide of silver, is put into a dark box, exposed to the light, and "there you have it!" But what? The negative; and this is only the first step in the process; one, indeed, that needs artistic feeling and knowledge, as we have tried to show in previous chapters, but only a step towards the ultimate result. The photographer so far has reached a point corresponding to that arrived at by the student when he succeeds in gaining admission to a university. It is then that the actual development of his character and mental machinery must begin: which course of study shall he select in order best to develop the inherent possibilities of his attainments and temperament? Just so the photographer is confronted with the choice of many ways of producing a print from his negative. The latter has certain qualities which suggest the advisability of using one out of these many processes, and the photographer has certain motives of his own which he thinks the negative can be made to yield. So by the choice of a method and by the skill and feeling with which he uses it will be determined whether the resultant print is an ordinary record of certain facts or an expression of individual artistic purpose.

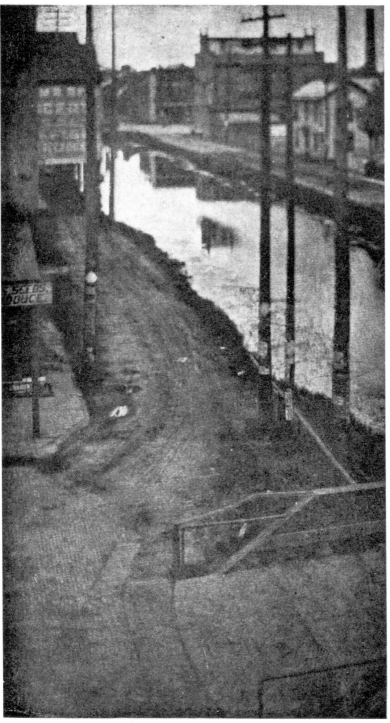

From a platinotype by Clarence H. White

"TELEGRAPH POLES"

PHOTOGRAPHY AS A FINE ART

It is here that the commercial photographer is apt to differ from those who can spare the time to treat the subject artistically. His objective is a definite financial profit; he cannot afford to experiment, and adopts a certain process which in the long run produces the best average of results and sticks to it. On the other hand, the photographer who allows himself the luxury of study and reflection, either varies his process according to the qualities of each negative, or if he make a practice of one process, preserves a continual attitude of experimenting in the care and thought with which he applies it or reapplies it until the result he has in mind and heart be reached. It is this which determines the money value of a print. Some readers may be surprised to know that considerably over one hundred dollars has been paid for many. Such an amount, however, they will agree is a small one to pay for an oil painting, because it is engrained in their minds that an oil painting is necessarily expensive. But why? Oil is cheap enough, paints not extravagantly dear, and neither canvas nor frames exorbitant in price. What we pay for is not these ingredients, but an added value, the indefinable something put into them by the personality of the artist. Equally it is not the price of paper and chemicals or even of the photographer's time at so much the hour that sums up the value of a photograph, but the skill and feeling of the operator which transmutes the result and makes it a work of art.

And how shall we know it for a work of art? you ask. Frankly, there is no comprehensive, infallible test, for feeling as well as fact is to be reckoned with; the fact, being certain rules of composition, themselves various and contradictory, differing, for example, in a Japanese

print and in a picture recognized by the academies of Europe; the feeling, a matter for ourselves to decide. If the picture affects us pleasurably, it is, at least to ourselves, a work of art. The fellow who " knows it all " may tell us we are wrong. Let us listen to his arguments; in time we may find he is right; perhaps, however, he is not right, having only his own store of facts and feelings to work by; meanwhile, we have got our enjoyment, and this way of thinkingly recognizing " what we like " brings with it a continuously developing appreciation and knowledge; our

By Clarence H. White
"PORTRAIT OF MRS. D."

old loves are replaced by others more congenial to our riper and wider judgment; we ourselves develop, and our taste correspondingly. But never be satisfied with the other fellow's dictum; let our judgments and fancies in the matter of art, whether right or wrong in others' eyes, be matters of our own conviction.

PHOTOGRAPHY AS A FINE ART

In the previous chapter various methods of manipulating the negative or print were considered. Here we will briefly touch on the platinotype and gum-bichromate methods of development, using them as pegs on which to hang a discussion of the work of Clarence H. White and of William B. Dyer; not exhaustively from the point of view either of the expert or the critic, but following our plan of treating various phases of the art and of illustrating them by reference to some of their leading exponents. All the prints of Mr. White, kindly submitted for this chapter, are platinotypes, while the best of Mr. Dyer's are gum-bichromates. Hence the adjustment of our thought. On the other hand, both these gentlemen frequently indulge in figure subjects, as distinguished from portraits or landscape. On this point, however, I shall touch but lightly, as it will be the topic specially considered in the next chapter.

Mr. White appears to find in the platinotype process the best expression of his purpose. When platinum paper is exposed to light in the printing frame the dark parts come out first in a temporary image of iron or silver, which in the subsequent process of development is, in some cases, overlaid with, in others exchanged for, a permanent image in metallic platinum. This is the scientific statement which may mean much or nothing to the reader; but the main thing is that the platinum, being distributed over the paper with exceeding fineness, yields exquisitely graduated tones of black and gray. This black, blue-black or brown-black, but deep and full of color, and the delicate differences of gray are the distinguishing characteristics of this process. It lends itself, therefore, equally to rich and dainty effects, and is in-

valuable when tender differences of tone are desired or sumptuous depth of color. For an example of the former may be cited the *Portrait of Mrs. D.*, in which the stiffness and glare of a white piqué costume is reduced to a mingling of soft radiance and equally soft shadow, daintily differentiated from the light wall behind the figure. The picture recalls a somewhat similar subject by the painter, John S. Sargent, inspired by the same artistic motive of preserving the freshness of the fabric while controlling its angularity and sharp obtrusiveness; and, although the painting has more style, the print is equally artistic in a more gracious manner.

It opens up a consideration of Mr. White's work from the artistic standpoint. After knowing his prints only in driblets at various exhibitions, I have had the pleasure on this occasion of examining over one hundred, and they offer quite a revelation. Probably there is not one in which genuine artistic feeling fails to appear. Moreover, it has been cultivated. He has mastered the principles of composition and trained his sense of line; places the figures excellently in their space, surrounds them with atmosphere, and distributes over and around them a fascinating web of light and shade, using also the simplest objects to complete the picture, but with a judgment that makes them contribute to the beauty of the design. In many prints, for example, recurs a little ice-chest, but its homeliness is forgotten in the suggestive way in which it has been used to secure a solid mass when such was needed. The most notable instance of Mr. White's ability to extract beauty from the homeliest material is the print entitled *Telegraph Poles*. The scene appears to be a canal, on the banks of which are poles and irregular

buildings, separated by vacant spaces, like teeth and stumps and gaps in an old crone's jaw——an unsightly, even squalid, spot, at least to the stranger; but to the man who has seen it under all sorts of aspects of light and weather, moreover, with an artist's eye, alive to the abstract fascination of mere lines and masses, of mingled

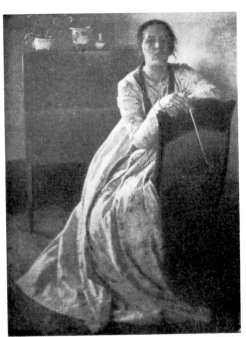

By Clarence H. White

"SELF-OBLIVIOUS"

variety of tone, this most unsuggestive subject has revealed possibilities which have yielded an original and strikingly beautiful picture.

If I am addressing any one who has hitherto regarded art as the mere imitating of objects, this picture should open up a new idea. It would seem that it is not so much the objects as the use which the artist makes of them that constitutes art, the little something of himself mixed in with the ingredients, the personal alchemy that transmutes the commonplace into the beautiful. So, if you want your portrait taken, it may be less important what clothes you wear than whom you select to photograph them.

A print that gives increasing satisfaction is *Self-oblivious*. In view of the simple elegance of the apartment (*simplex*

munditiis, as Horace, writing in the days of Roman osten-
tation, has it), and the dainty artifice of the little bits of
china and foliage-sprays, I dare to be honest and to
express a wish that the impetuosity of the artist had
allowed the lady time to finish the arrangement of her
hair. Its disarray troubles
the serenity of the composi-
tion; but, accepting it as we
find it, how dignified is the
picture with its ample pas-
sages of dark and volumin-
ous mass of lighter drapery,
the latter so simple and yet
expressive in its well-chosen
lines. One may find the
lighter contour of the dress
a little hard and insistent,
lacking in atmosphere, and
while on this subject may
refer to the print entitled
The Puritan, an upright
panel with the standing
figure of a woman seen in
profile. In the soft rim of
light down the front of the
dress there is greater mystery,
and more subtlety in the

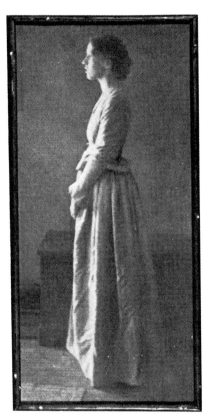

By Clarence H. White
"THE PURITAN"

relation of the darker tones and in their differentiation
from the background; and these qualities have a
direct artistic reference to the feeling and senti-
ment of the picture. What exceeding simplicity there
is in the composition, its frank contrast of long up-

right lines with a horizontal mass (the ice-chest by the way). It emphasizes most admirably a point that many a young photographer might well take to heart—that there is no necessary virture in elaboration, but that the simplest principles, cunningly applied, will yield most satisfactory results. In both these last two prints the key-note is simplicity; in the one case with a large suggestion, in the other with a gentle reticence.

Let us compare with these the subject *What Shall I Say?* a young lady seated before a writing bureau. This seems by comparison a manufactured article; cleverly devised, no doubt, but lacking—what? Apparently simplicity, which might have been secured by merging into masses some of the separate details. The lace curtain, patterned carpet and chair trouble us with distinct definition; the paraphernalia of the bureau, on the other hand, is sketchily suggestive, giving an idea of papers and litter of stationery without the facts being forced upon our notice. This part of the picture is impressionistic, the before-mentioned details obvious and by contrast commonplace. The lady, again, is charmingly presented, but the pose lacks spontaneity; she did not assume it temporarily, one feels she was put there and will stay. I dwell upon these points because this is just the sort of a picture that amuses the inexpert, like those pretty oil paintings of the Düsseldorf school and of some of our own painters with their "seeing's believing" accuracy of definition and "what-a-lot-for-your-money" profusion of detail. It lacks simplicity, synthesis, and spontaneousness, being too diffusive and insistent upon trifles.

Compare with it the print called *Evening—Interior*; light filtering in through windows upon a seated woman;

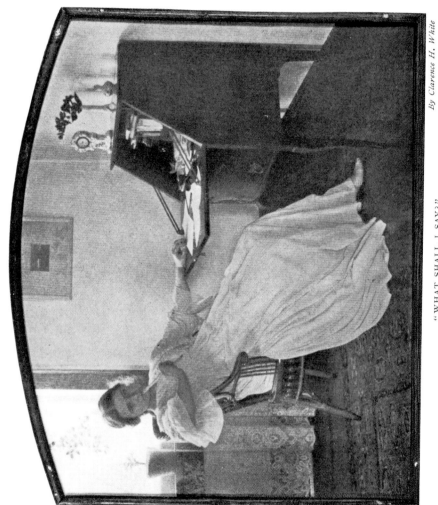

By Clarence H. White

"WHAT SHALL I SAY?"

everything told in a moment, nothing interfering with the suggestion of peace and restfulness—a true bit of impressionism. The picture is saturated with tranquil light, even the shadowed parts of the wall and the woman's figure being luminous; there is no shock of light and dark, but, as it were, a pervasiveness of musing quiet. Surely, if we prefer to have our imagination stimulated rather than to have a little statement of fact categorically related, we shall prefer this picture to the *What Shall I Say?* The management of the light in this *Evening* suggests a reference to the landscape with *Sheep.* The original is steeped in warm atmosphere. Looking at the picture one seems to feel the atmosphere, and the quality of fading light is equally well suggested. The tops of the trees are dark against the sky, but lower down their shadows are still loose and luminous; light still lingers on the sloping banks and glints on the fleece of the sheep. As you peer into the dark spots of the picture, hints of detail are faintly visible, and curious and unexpected pranks of light, which lend a mystery and suggestiveness, such as the scene would have in nature. These subtle effects, as was urged in the previous chapter, seem to be one great advantage of a "straight" photograph, skillfully controlled, over the much manipulated print, which must depend chiefly on broad and general effects. This subject of *Sheep* is printed in tones of warm brown; hence, I fancy, the suggestion of evening, whereas, if delicate grays had been used, it would probably have been an equally true representation of very early morning. If this be so, it gives a clue to the range of possibilities in treating the negative, so as to make it yield what the operator desires. And let not any painter smile at this turning of morning

into evening effect, or *vice versa*, at will, for it is often difficult in an oil painting to decide which of the two hours has been intended. The phenomena of both are often very similar, differing only in the degree of warmth or coolness in the atmosphere; and as the morning may be warm and the evening cool, even this distinction is not always reliable; and age, too, yellow pictures, so one may not infrequently be in doubt.

The early morning suggestion, by use of gray tones, is beautifully represented in the picture of a lady walking in a garden entitled *Morning*. The cool light steals softly through the early mistiness of atmosphere, sprinkling leaves and flowers, and creeping under the bushy masses of the apple tree. What a pure and fragrant scene, and how charmingly the figure is treated, detached so tenderly from its surroundings, and yet in feeling and placing entirely a part of them! The picture is as dainty as a fragment of rose-point lace, the darker mass of the lady's head being the embossed centre of the design; it might have been breathed upon the paper and yet the evanescent appearance will be permanent—one of the benefits of the platinotype process. And note, this tenderness is not obtained at the expense of reality and substance. The figure is very tangible, the path solid and sufficiently detailed, the nearby foliage detaches itself in parts, and the distance under the apple trees is suggested. Only these are blurred, as they might be in nature at this hour. I mention this because there is a prevalent notion that the necessary and infallible recipe for tenderness in a picture is blurr and muzziness. One often sees such pictures, consisting merely of several masses of tone melting into one another; very pretty, but inadequate as studies of nature

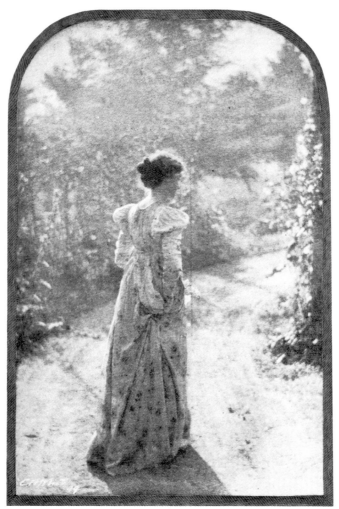

By Clarence H. White

"MORNING"

because they generalize too much and obliterate the sense of facts. It is a virtue of this one that, while the facts are subordinated to the general impression, they are sufficiently indicated to ensure a ready acceptance of them as real and beautiful in themselves. On the other hand, the charm of *At the Window*—another design of delicate grays—would have been much increased if some hint of

the scene outside the window had been given. As it is, the lady draws back the transparent curtain to reveal nothing but formless and unlovely blurs. You will agree at once that the diffused atmospheric effect has much to do with the beauty of this picture; but, lest it should seem essential, compare *The Readers*, in which everything is shown in clear light. The subject is full of pensive tranquillity, and yet there is no muzziness; on the contrary, a strong composition of well-defined darks and lights and intermediate tones, a pattern admirably bold and emphatic. Its harmonious quiet is the result of serene, unbroken lines, ample simplicity of spacing, and the complete balance preserved in the masses and tones.

In most of these prints the composition has been deliberately arranged with a decorative end in view. A fine example is seen in the *Portrait of Mrs. D.*, which attracts for another reason: that it is the only subject illustrated here in which Mr. White has shown an artist's joy in the beauty of rounded flesh; the play of full light on the soft boss of the shoulder, and the showing of the firmly modelled arm through the delicate mesh of the sleeve. Moreover, there is a languorous ease about this picture, which is pleasant by way of occasional contrast to the strained earnestness in some of the others. We do not care a fig for a man who is not in earnest, yet the earnestness should not obtrude; it should be felt rather than clearly stated. In some of these prints the model is keyed up to such a serious consciousness of the part she is playing that we ourselves experience a sense of strain and fatigue. With most photographers the difficulty is to find a model that can enter into their motives. Mr. White has been more fortunate. Two ladies appear and reappear

throughout his pictures, and to their intelligence and sympathy he owes, no doubt, a large measure of the beautiful results secured. I cannot but feel, however, that they would often help the picture by a little more lightsomeness of feeling. In the well-rounded artistic temperament there seems always to be a savor of this, even an occasional petulance of contempt for art, as being, after all, so inadequate to express everything the artist has to say. It acts as salt to the imagination, keeping it fresh and racy; helps the artist to step outside himself and see what he is doing as a man; prevents him from circling too persistently around the centre of himself, and widens the orbit until its direction appears to be spontaneous. In a spirit of sympathy with Mr. White's motives, and out of admiration for his work, I commend this thought to his reflection.

So far we have been discussing platinotypes, almost all of them "straight" prints, such manipulation as occurs being only to secure a loosening of the color in the shadowed parts. Mr. Dyer also works in this medium, but the examples I have selected introduce us to the gumbichromate process, for in this he seems to have accomplished the most notable results. Color and tone would appear to be the qualities that he best understands, for in composition he shows weakness, the lines and masses being often angular, jerky, and harsh, and the patterns confused. But in the gum-bichromate process, wherein tone and color count so much, he has struck a vein which should yield rich results.

The process, briefly, is as follows: The operator, having taken his negative, prepares the paper for printing by spreading it with a mixture of gum, water color, and

potassium bichromate. When the coating is dry the paper is exposed to the light through a negative in a printing frame in the usual manner. The sunlight renders the gum insoluble, in proportion to the amount of light which gets through the negative. Thus under the clearest parts (which, it will be remembered, represent the shadows of the actual picture) the gum becomes insoluble, while under the darkest parts (which will be the lightest) the gum remains soluble, and a gradation of insolubility is reached

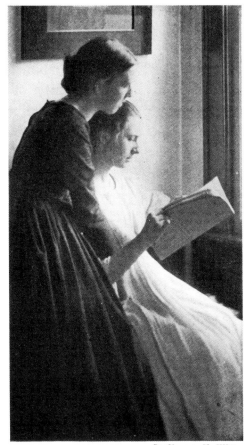

By Clarence H. White

"THE READERS"

in the intermediate parts. The paper is then washed in water, which removes the gum according to the degree of its solubility, and with the gum the coloring matter in it. If the photographer leaves the paper in the printing frame until the light has accomplished its work thoroughly, the result will be a straight photograph. But if he takes it out after an exposure merely sufficient to indicate the outlines of the image, he can, by simple application of water, remove much or little or all of the

gum in any part he wishes. In this way he is able to modify the tones, remove any details, and to entirely alter the character of the subject. Through this complete freedom of manipulation, joined to a wide range in the choice of color and quality of paper, this process offers the greatest possibilities of personal expression, and in the hands of any one of artistic knowledge, as well as artistic temperament, may be made to give surprisingly beautiful results in certain subjects. For it is not suitable in all cases. "It is generally said to be specially indicated for broad, sketchy effects," writes Mr. F. A. Waugh, an expert of the process, in *The Photo Miniature* "and perhaps this phrase comes as near covering the case as can anything short of personal experience. I find it particu-

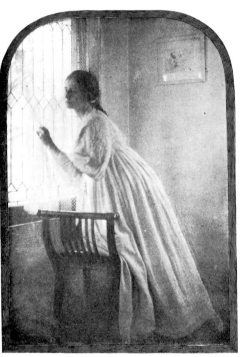

larly useful for the fine texture it gives, especially with lampblack. This texture gives the best rendering I have ever seen for old mossy stones, for dilapidated architectural masses, light and shadow on old tree trunks, and the like. It is incomparably useful in showing trees, especially when leafless, and when only the outlines of the trunks and tops or the tracery of the branches

By Clarence H. White

"AT THE WINDOW"

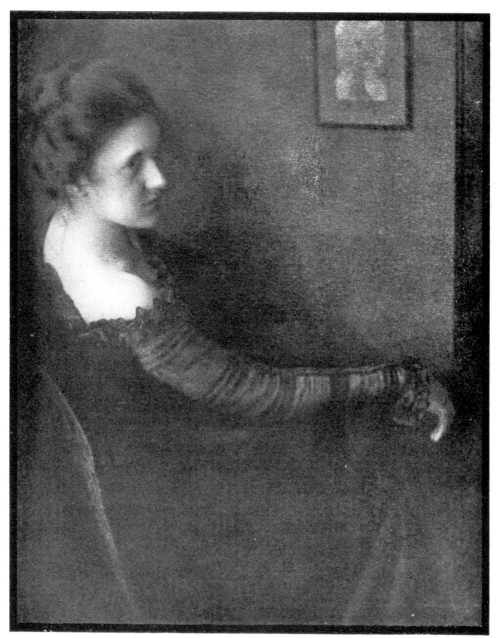

"PORTRAIT OF MRS. D." *By Clarence H. White*

is wanted. I find it difficult to interpret water surfaces in most composition (though not in all) by this process. It is difficult to print in clouds which may be in the negative, but supremely easy to 'fake' in clouds not in the negative. . . . It is not generally useful for portraiture, though it gives the happiest results in certain cases."

It will be noticed that Mr. Waugh uses the term "fake," placing it, however, in quotation, for elsewhere in his interesting brochure he alludes to it as a charge brought by others against the manipulation of prints, whereas he claims the right to do anything to secure the desired result. In the previous paper I tried to sum up a just conclusion of this matter, and what was said in relation to the glycerine process may fairly be urged in connection with the gum-bichromate. Successful manipulation demands artistic training, the ability to draw, as well as the trained eye for values and tones, and the results in this process will be of a "broad and sketchy" kind. This last statement seems to bear out what I said in speaking of the glycerine process, and that both these methods of printing are unsuited to subtle effects and delicate distinctions of tone, as, for example, appear in some landscapes. The point is worth insisting upon, for the fascinating liberty of action which both allow the operator may easily blind him to their deficiencies. On the other hand, there are possibilities in the gum-bichromate process of printing which fully justify the enthusiasm of those who use it and their belief that it offers the most fertile soil for further development of the art. A well-known "straight" photographer tells me (very significantly) that, if he had the requisite skill in drawing, he

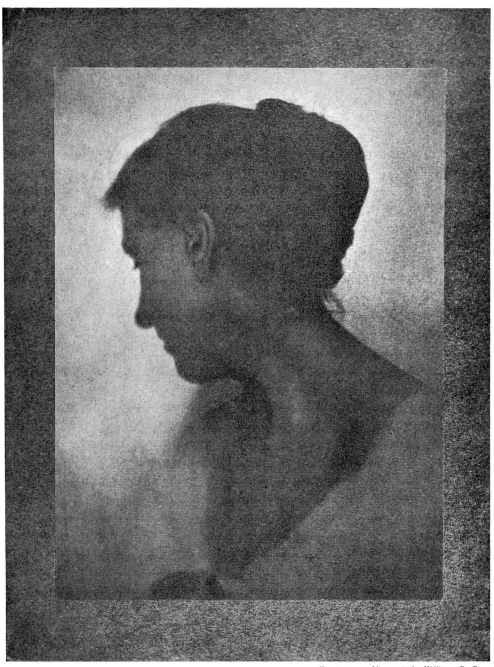

From a gum-bicromate by William B. Dyer

"STUDY OF A HEAD"

would be devoted to the process; though, he adds, not so much to change as to modify the straight record of the negative. I fancy, however, that when his enthusiasm became aroused over a certain point, he might easily find himself going beyond this self-appointed boundary. "The wind bloweth where it listeth, and ye cannot tell whence it cometh or whither it goeth;" the wind, in this case of personal expression, trying to free itself.

Mr. Dyer, so far as I know, has limited the use of this process to idealized representations of the human figure. The originals of the examples illustrated here are colored brownish-red in the darker parts and warm buff in the lights, and, except for the merging of the drapery into the background, are straight prints from negatives a little under-exposed. I find it difficult to take an interest in *Before Agincourt*; it conveys little meaning, and its sentiment seems concocted; nor are the lines agreeable, the arm and open sleeve being particularly devoid of feeling, while the lower part of the figure is not accounted for or its support sufficiently indicated. But the *Study of a Head* has many beautiful qualities. The design is bold, while the sentiment is tender and dreamy; there is impressiveness of mass and mystery of parts; beauty of firm, ripe flesh, and pleasant contrast of foamy drapery; agreeable color and real suggestion of atmosphere. While the figure in the other picture seems fading into or out of the wall, you feel that there is space beyond this head, that itself is real and tangible, and the haze which envelops it is luminous and penetrable. One wonders if the negative were taken in the open air. Certainly this method of using the process to secure flat tints, modelled but slightly, would suggest its suitability for out-of-door

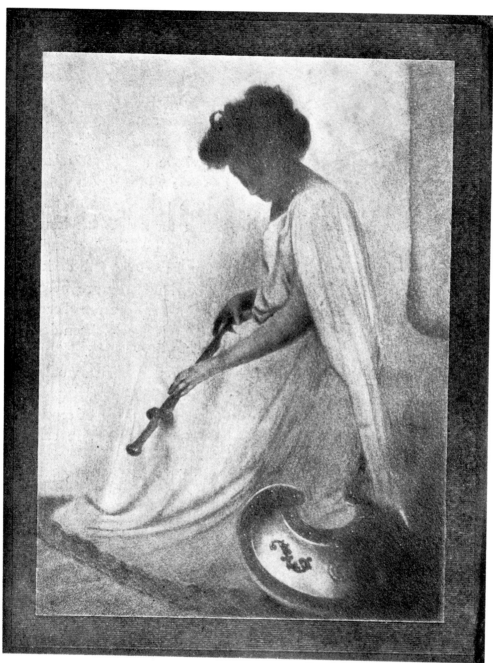

From a gum-bichromate by William B. Dyer

"BEFORE AGINCOURT"

studies of the human figure. For it may not have occurred to every reader that in a studio the light, being partial, is accompanied by shadows which throw the modelling up in strong relief, but that the greater diffusion of light in the open air reduces the appearance of bulk in objects; flattens them, in fact, and for contrasts of light and shadow substitutes faintly different planes of tone. If, therefore, Mr. Dyer's experiments have not already led him in this direction, one may hope he will essay it.

We shall realize more fully the possibilities of the gum-bichromate process, if we think for a moment how the print might have been developed. The background, instead of being washed away, might have been left dark, the head merging into it; or the head might have been made light as a contrast, or lights might have been introduced in parts of it; the drapery might have been defined or indicated merely by a few sketchy lines. Any one of these devices, and doubtless there are others, would have transformed the character of the pictures, giving it not only a different appearance, but another kind of sentiment. No wonder the operator is fascinated! He can improvise like a pianist upon the keys.

In this and the previous chapter I have tried to explain some of the ways in which photographers can control, modify, and even alter the statement of the camera; not, indeed, exhaustively; touching, in fact, only "the fringe upon the petticoat," yet surely enough to make clear that, if they are artists by temperament and training, they can make their print a medium of personal expression. Like the painters, they may not always try to nor always succeed when they try; but the possibilities are within their reach, and many photographers have grasped them.

PHOTOGRAPHY AS A FINE ART

To admit this is to recognize photography as one of the fine arts. For do not let us be cheated by a name. There is much in painting, in sculpture, and architecture which bears the same relation to Art (with a capital letter) as the husk bears to the grain; necessary in the evolution of things, but unsatisfactory as nutriment. If a picture speaks right home to me, or I know that it has to generations of men before me, I hail it as a work of art; if it merely gives me a record of facts, more or less perfectly represented, it leaves me cold, and I count it only journeyman's work. So, while the photographs that figure in the shop windows very often contradict all recognized canons of art, there are others, such as those we have been considering, and many more, which not only satisfy a cultivated taste, but bring to one a personal message, a hint of human character, a whiff of fresh country air, or the poetic fancy of an artist's mind. Such are acceptable as works of art.

CHAPTER VI.

"PORTRAIT OF ALPHONSE MUCHA"　　By Edward J. Steichen

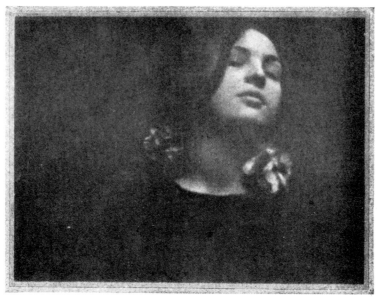

"THE ROSE" *By Edward J. Steichen*

CHAPTER VI

THE LANDSCAPE SUBJECT

ILLUSTRATED BY REFERENCE TO THE WORK OF EDWARD J. STEICHEN

S a preliminary to the Landscape Subject in photography, let us briefly glance at the pedigree of landscape in painting, for the latter has developed along certain motives which are still in force, and belong as much to photography as to painting.

The landscape in art was first studied and used as a background to figures. So we find it in the works of the Italians, where the painter's motive was to furnish a decorative pattern of form and color behind the figure, to surround the figure with atmosphere, and to contrast its

closeness and predominance with the subsidiary charm of vaguer distance; in fact, to set the figure in a concave space of light and atmosphere, somewhat as the sculptor puts his statue in a niche of architecture. It was not until the seventeenth century that landscape was studied really for its own sake and assumed an independent importance. Then, immediately, from this single source of the dignity of landscape start two separate streams of motive: the naturalistic and the artificial. The former, which aims to depict nature as it really is, was the motive of the Dutch painters, preëminently of Hobbema; while the latter, which would represent nature as the painter conceived it was desirable it should be, was followed by the French painters, Nicolas Poussin and Claude Lorrain. Poussin spent most of his life in Italy, and being saturated with classical lore and the influence of grand architecture and of tower-crowned hills, painted the so-called heroic landscape, largely as backgrounds for his figure compositions of heroes. The reputation accorded to his work in France laid the foundation of the classic or academic school of French landscape. Claude, his contemporary, while relying more upon the landscape than the figures, emulated this classic motive, building up imaginary scenes of great beauty, but with only a partial reference to nature, bearing, indeed, about the same relation to it that Virgil's descriptions of scenery bear to Tennyson's. It is interesting to note, by the way, that when the reaction began in England against the old-fashioned gardens, which had gone to extravagance of artificiality in such features as the cutting or "pleaching" of trees and shrubs to imitate the forms of birds and animals, the landscape gardeners who urged a return to nature actually set themselves to imitating

the artificiality of Claude's landscapes! When landscape painting was begun in England, Constable followed Hobbema; while later on Turner, in the early part of his career, was influenced by Claude Lorrain. The French movement of the Fontainebleau-Barbizon painters was a revolt from the artificial formality of the classic landscape and a return to the nature-study of the Dutch; a recognition also of the charm of the simple, familiar country-side—the *paysage intime*—as compared with the heroic of man's imagination or the stupendous phenomena of nature's self. The latest movement—that of the *plein-airists*, or open-air painters—is but a pushing of nature-study to closer intimacy, with a special desire to express the beauty of light and atmosphere.

Today few painters indulge in the classic landscape unless as an accompaniment to mural decoration, yet the distinction in motive between nature as it is and what the painter imagines it might be still survives. Some draw upon their imagination for subjects and paint the land-scape frankly out of their heads; others draw from nature, but with application of school and studio recipes for depicting the evanescent, elastic, and constantly varying aspects of nature; and even amongst those who loyally take her for their guide, philosopher, and friend this distinction asserts itself as the result of their mental attitude towards nature.

It has been the fashion, both in literature and pictures, to represent nature as corresponding very sympathetically with the vicissitudes and moods of humanity. Thus it is proper that the sun should smile upon the virtuous heroine while the welkin gapes with lightning and rumbles thunderously over the doomed head of the villain. This

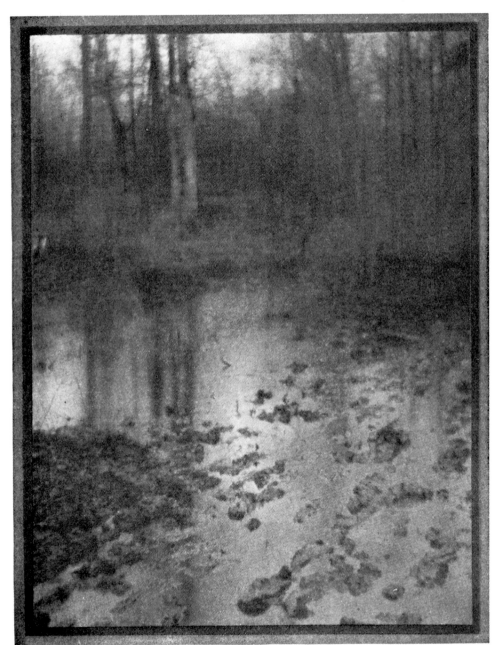

"THE POOL—EVENING"

By Edward J. Steichen

affectation of the Romanticists, beginning with Byron among writers and with Géricault among painters, is dying a lingering death in the obscurity of the bucolic-domestic drama. Yet the fact remains that, though nature is absolutely insensate, just as likely to be gay over a child's corpse as to drench a bridal party, we do find in her relentless routine of changes both an inspiration to emotion and a correspondence to our moods. Looking out to sea when a fresh breeze is ruffling the water and the little waves dance to one another and play ball with the sunshine, we must be in poor case if we do not feel an exhilaration, or when we stand in the rarefied air of the mountains, with spaciousness on all sides, above and beneath us; scarcely, either, can we miss the sweet allurement of nature settling to repose at sunset; and, if one's mind is ragged with worry or the heart torn with grief, I know no better tonic and solace than to walk on and on with rain and wind against one's face. After all this inert thing, nature, is a perpetual source of sympathy and inspiration, having in it a latent poetry. It was this that the Fontainebleau-Barbizon painters sought for, and accordingly painted poetic landscapes, as innumerable painters are doing today.

It would seem, however, that there are two ways of essaying the poetic landscape—one, in which the artist lets nature tell her own story; the other in which he makes her the interpreter of his. Of the latter method Corot was a preëminent example, always true to the facts of nature, but choosing to depict those which harmonized with his own sweet tenderness of disposition. Rousseau, on the other hand, like Monet today, and like our own deceased painter George Inness, seems to have found a sufficiency in nature. Having no desire to express an

antecedent emotion of his own, he paints nature objectively but with such enthusiasm and loyalty to truth that he succeeds in grasping her latent poetry. There need be no question of which is the better way. The motive, reaching in each case a corresponding result, is dictated by the artist's individual temperament. But the point of importance to ourselves is that the picture, whether it reflects the feeling of the artist or embodies the impersonal poetry of nature, shall be able to affect us with some recognizable emotion; that it shall not be a bare inventory of facts, but express something of the relation between those facts and our own lives.

At first sight it might seem that the photographer has no option as to motive; that he is obliged to record nature as it is, and that the camera, in its appetite for detail, will insist mainly upon the facts. This suspicion is certainly indorsed by the great majority of photographers, wherein excessive definition is the prevailing quality. On the other hand, in the two previous chapters we have seen how the photographer can control the result during the process of printing, by elimination, addition, or even by complete alteration. So in his case also the distinction of motive intervenes—shall he adhere to the mere facts of the camera, or modify them; and, if the latter, shall it be in the direction of nature as it is or of nature as his fancy would imagine it?

I have continually used the expression "nature as it is" for convenience sake, with intentional, though, I hope, pardonable inaccuracy; for we speak of nature as being so and so, when we really mean that it *appears* to be so and so to ourselves. But to each individual observer it manifests more or less variation of appearance, for each man

sees only what he has the capacity for seeing —that is to say, his vision is affected on the one hand by the individual character of his pair of eyes, on the other by his power of observation, by the experience of what he has seen before, and by the likes and dislikes of his temperament, which lead him to look for certain things in preference to others. His physical apparatus for

By Edward J. Steichen

"THE BROOK IN WINTER"

seeing is not an insensate machine, but an instrument delicately sensitive to conscious and unconscious modulations. Now the camera is not. It records what it sees mechanically and, more than that, with an eye whose way of seeing and recording differs from our own. When, for example, we look at a tree, we cannot distinguish separately all the leaves in sight or take in at a glance the labyrinth of boughs and twigs; the latter compose into a general character of structure and direction, the foliage into a mass or arrangement of masses. Further, as we gaze over a distance the landscape recedes by easy stages, the eye readjusting its focus as the gaze travels forward. But the camera's focus is fixed; it is apt to give a surplus of definition in the foreground and to jump abruptly to vagueness in the back-

ground. The human way of seeing may be summed up as follows:

First—Our eyes have a tendency to generalize; that is to say, to make selection and to arrange in masses.

Secondly—Experience is constantly reinforcing our vision. We know that the meadow is covered with blades of grass and that the tree's mass is really an aggregation of infinite detail, and this experience supplies the deficiencies of vision through the imagination.

Relying on these principles or habits of seeing, the landscape painter or photographer, if he follow the best traditions of art (those, in fact, which are truest to nature), generalizes the scene, making an abstract of its larger aspects and most characteristic features, and giving just enough suggestion of detail to stir the imagination to realize their existence. On the other hand, the painter or photographer who niggles over details is losing the big in the little, interesting merely our eye and making no appeal to our imagination. Again, all of us, if we think about it, know that the landscape does not mass itself on one plane, but on many, one behind the other, and that this is one of the sources of beauty in nature. For there is exhilaration in the sense of space, a certain mystery and enticement to the imagination in distance; moreover, the beauty of nature's coloring is largely influenced by the tender gradations of hue caused by the intervening screens of atmosphere. The painter renders these by infinitesimal differences of color, proceeding in orderly sequence from the front to the horizon. The photographer, limited to one color, attains the same result by varying its tones—in the platinotype print, for example, securing between the darkest black and the brightest light a modulated scale of

delicately different grays. Upon the feeling and skill with which these "values" are adjusted will depend much of the effect on our imagination; we shall not be troubled by the absence of colors—they have been transposed into an abstract key of black and white, with enough suggestion of relative truth to nature to arouse in our imagination the sense of color. And I wonder whether it is not true that our enjoyment of nature depends less on color than upon the action of light? It may be otherwise with the glorious hues of autumn or of an Indian summer, but I am writing this in early spring, with a view from my window of a picture in tones of green framed in by the casement. Yesterday the sky was lowering, and in the dull light the grass and foliage, for all its fresh vitality, seemed inert. Today the sunshine has awakened them to animation, but with difference of expression. The leaves of the maple glance, open-faced, to the sun; the elm's are peeping shyly from their buds; the chestnut's, still frond-like, cling together for company in the cosiness of their woolly coverings, while the pine's are strong in color and vigor, as befits one who has weathered the winter and grown confident with experience. But on all these variations of green the light is playing differently—with broad welcome, coaxing tenderness, or the heartiness of old companionship—and there is a similar variety of expression in the shadows. I am reminded, too, that color is reflected light, that light is the source of life, and that the rendering of it in its endless manifestations is the absorbing motive of many great painters. So, perhaps, I am not far wrong in saying that light affects our imagination even more than color, and therefore that a good photograph, which reaches its beauty through its inter-

pretation of the manifold aspects of light, may yield us as much enjoyment as a painting—certainly far more than a poor painting, possibly as much as a good one. For we ought not to be like children, continually demanding literalness, forever asking *Why?* and expecting their elders to make all the explanation and to do all the thinking for them. We ought to have imagination enough to need only a hint and then be able to fill in for ourselves the full conception. Let us not forget, either, that a work of art, whether painting or photograph, is at best only an abstract interpretation of the actual thing—a legitimate make-believe which demands of us the willingness and capacity to realize through the deception the thing represented. You may have seen one of Whistler's Venetian etchings—the most abstract of records, merely a very few black lines and a great deal of white paper, which, however, supplemented by our own knowledge and imagination (I keep talking of imagination—what is it but the faculty of adapting what we *do* know to what we *might* know?) enables us to picture to ourselves the color and indwelling spirit of Venice. Equally we shall find that many photographs of landscape have this emotional suggestion; not

By Edward J. Steichen

"WILD CROCUS"

all, certainly, any more than all etchings or all
paintings; it is not a question of the medium em-
ployed, but the amount of feeling which the artist
puts into his picture. And if you ask me what I mean
by this much-used and not seldom abused word, "feeling,"
I will venture to define it (at any rate, for our present
purpose) as that quality in a picture which starts some
fibre in ourselves vibrating with memory, hope, or longing,
with some emotion sad or pleasurable, as a piano string
vibrates in sympathy with a note of the human voice.

The accompanying reproductions of landscape by
Edward J. Steichen will show that he sees in it a subject
either for the realizing of some artistic problem or for
the expression of some emotional suggestion, or both.
For he is to the marrow an artist; one can detect it in
all his prints. Some of them we may not care for as
pictures—probably they were only experiments, very likely
inadequate in expressing what he strove to reach, but,
even so, they are artistically interesting and bear in
consequence an impress of distinction. This is a quality
more easy to feel than to explain. Broadly speaking, it is
the antithesis of the obvious; getting closer home, it is
seeing nature through a vision that transposes the facts
into an abstract of form, color, light, and atmosphere, and
this with such vividness and power of expression that the
result is in a greater or less degree a new thing—a creation.
His faculty of expression is not limited to photography,
since he is an excellent draughtsman in a variety of
mediums and has had an oil painting admitted to the
recent Paris Salon. It is, therefore, interesting to know
that he has recourse to photography, because he finds
that in some cases he can reach by means of it better

results than in any other way. In his hands it is not a makeshift, but a separate source of power. One would like to question him as to what those cases are. A general pondering of the subject and particular study of his prints leads one to the conclusion that it is when delicacy of tone is desired as a prevailing quality. Perhaps also richness of tone (note his portrait of *Mucha* and *The Rose*, the latter reproduced on page 145), although that is readily within the scope of oil-paint and etching, whereas delicacy of tone is much more difficult to obtain —in painting, because the variety of hues tends to confuse the issue ; and in etching, because the process permits the introduction of only a few of the planes, so that tenderly proceeding gradation is well-nigh impossible, while in a platinotype print the range of greys between the darkest and the lightest parts is susceptible of almost unlimited subtlety. Perhaps also photography attracts him in another direction—in the readiness with which it can be made to express the flatness of objects. It was mentioned in a previous chapter that the greater diffusion of light out of doors tends to flatten objects—that is, to reduce the appearance of bulk which they assume in the partial light of the studio, where the shadows, more insistent by reason of concentration, throw the forms up in strong relief. Through all these landscapes of Mr. Steichen's there is appreciable the enjoyment which he feels in this flat pattern of form ; although, observe, it is not a flattening of the objects against the front of the picture, but an extension of the principle that they count as masses, silhouetted against what is beyond. If you ask why an artist should find enjoyment in this, I may conjecture that it is because it adds another feature of abstraction to the

By Edward J. Steichen

"THE RIVULET"

already abstract conception of the landscape, and thereby increases his sense of mastery over his medium, in that by means so opposed to the facts of nature he can suggest an impression of nature's appearance. It is worth remembering that the Japanese, whose art is the most abstract that we know of, founded upon generations of tradition and brought to the finest point of eloquent suggestiveness, include among their resources this of flatness.

Possibly a characteristic example, combining those two qualities of flatness and tonal delicacy, is *The Pool, Evening*. One utters a prayer for the safe delivery of this delicately subtle print from the perils of the half-tone process! The latter will at least reproduce the flat massing of dark and darkening light, just the features that would first arrest one's attention if confronted with the actual scene; but will it render the ebbing pulsations of light upon the water or the mysterious penetrability of the shadowed wood beyond? These, again, are the features which, if we lingered around the spot, we should gradually observe; noticing later the charming disorder of leaves that float on the placid surface, so unobtrusive although they are in the foreground, and by degrees yielding to the spell of sweet solemnity that pervades the scene. Do we regret the absence of various hues of color? The picture is full of the *sense* of color, and the very reticence of the black and white permits a freer movement to our imagination.

This is one of those prints which emphasizes the wide gap there is between the average photograph and genuinely artistic work. Perhaps, if I were an expert operator, I might undertake to tell you "how it was done"; that the negative was over-exposed or under-exposed, or the camera

focused on the background, or that some other shrewd technical device had been adopted—pecking trivially around the big qualities of the picture and making believe that I or any other "expert operator," using such

By Edward J. Steichen

"THE JUDGMENT OF PARIS—LANDSCAPE ARRANGEMENT"

and such a camera and such and such a negative, lens, or stop, and printing according to such and such a process, could have produced a similar result. Fortunately for my own enjoyment and, I hope, for yours, I am only a

sympathetic observer of other men's work, and concerned a great deal more with the pictorial result than with the technicalities of process. As to the latter, however, I am inclined to smile incredulously and invite the "expert operator" to repeat them; in which case I fancy there would still be some little discrepancy in the result, for he seems to have overlooked the personal ingredient, the thimbleful of artistic yeast that raises the lumpish dough. The real difference between this print and the average photograph is the same as that between some paintings and the majority of them; the difference, indeed, between mere technical accomplishment and the same quickened into vital expression by the spirit of the artist—the difference, in a word, between craftsmanship and art. I set this print and some others of Mr. Steichen's alongside as many landscape pictures by other photographers (the latter what you would call handsome but very literal interpretations of nature) and invited a child of twelve, who is devoted to country life, to tell me which she liked the best. After some little while she selected this print of *The Pool*, and when I asked her why, replied: "Because it is so real." Apparently the literalness of some of the other prints had not conveyed an equal suggestion of reality.

Of the other landscapes by Mr. Steichen, reproduced here, that which comes nearest in quality and interest to the one we have been considering is *The Judgment of Paris—Landscape Arrangement*. This *Landscape Arrangement*, as the name would imply, is rather a study of composition, of forms and spaces, and of varieties of light and tone than a picture with emotional significance. A *Decorative Landscape Study* which, however, I have not

been able to reproduce in this article, is an essay of a similar character, but carried to a farther point of generalization, until the whole has been reduced to a flat pattern of forms and spaces in a very limited range of tone. The motive is not a realization of nature, but an abstract of its possibilities in the direction of ornamental pattern. The expanse of meadow in *Wild Crocus*, the level line near the top of the picture, the soft silhouette of trees and hill against the quiet sky, and the smooth masses of slightly contrasted tone may be compared with the more stirring contrasts of line and color in *The Brook in Winter*—the one so reposeful, the other suggestive of un-satisfied yearning.

In all these prints, though they permit only a limited estimate of the range of Mr. Steichen's ability, there is visible the impress of a true artist. Whether they have much or little or no emotional significance, they are always distinguished by individuality. It is not the obvious but what is concealed behind it that he tries to reach, and his search is not only stimulated by a virile personality but guided and controlled by artistic temperament and training.

I have spoken of the " obvious " and must try to justify the use of the word. We admit the beauty of nature and that the artist renders this beauty through faithful study of what he sees; therefore, the " obvious," that which confronts his actual vision, might seem to be the truth of nature and accordingly desirable. Unquestionably it is the truth but a truth that is only the outworks, as it were, of a greater truth. In a bottle of perfume it is the essence which we cannot see and not the water which is plain to sight that constitutes its charm. So, latent within the

forms and colors of the landscape, is an essence or spirit. It was not, for instance, any particular evening that Corot painted but the spirit of eventide; and when Rousseau painted a fragment of the hard-ribbed earth and a mighty oak gripping the soil with its roots and flinging its giant arms to the sky, it was because he was conscious all the time of the grandeur of nature's forms, that this minute record partakes of the grandeur of the whole big scheme of nature. Both looked beyond the obvious; one to the spirit or soul of the landscape, the other to the elemental force of its material manifestations.

And to a greater or less degree every true lover of nature views her in somewhat such a manner. It means far more to his heart than to his eyes. It may be the exquisite serenity that broods over the meadow and clump of trees, or, on another occasion, the purity and freshness of reawakening life that steals over the simple scene and makes his own blood flow more quickly; or, again, the expansive comfort of summer or the turbulent stimulus of the time of fruitage—these are but trifles of suggestion, though enough, perhaps, to remind us that we do ourselves look beyond the obvious. This, too, explains why some phases of nature cannot be adequately rendered in painting or photography; the grandeur of mountain scenery, for example; when the spirit of the scene is so overpoweringly greater than the mere physical aggregation of the parts; and yet it is through the representation of those parts that the artist is forced to proceed. However faithfully he reproduces them, the mightiness beyond eludes him; or, indeed, one might say that the more faithfully he renders them, the less will he attain to their inherent grandeur. Any one who has tasted of the

T. Ridgway Moore

"THE MARSHES—FLORIDA"

exultation, awe or sublimity that mountain scenes suggest, knows how comparatively petty is the impression of the pictorial record of them. You may recall a picture of an avalanche in the National Gallery, by Turner, which does convey some measure of this impressiveness, but it is because he did not make the rendering of the snow his chief motive but the force and fury of movement. He has tried to paint the abstract impression rather than the concrete, obvious fact.

Now, as very few of us in these days are Pantheists, I presume we use the expression "soul or spirit of nature" as a mere convenient metaphor. We conceive of it as existing not in nature herself but in the man who studies her with love. It is the artist's subjective point of view. Opposed to this is the objective; that of the photographer, for example, who exclaims "What a beautiful view!" and snaps it off. But we cannot reach the soul of a woman by a hurried recognition of her beauty; and nature is at least as impenetrable to such casual admirers. Yet this is the way in which thousands of photographs are made and with which, unfortunately, both their authors and the public seem very well satisfied. Perhaps it is unkind to disturb their satisfaction, and equally futile to try and explain why they should not be satisfied. But pardon me for attempting it, as, at least, it will summarize the points we have been discussing in this chapter.

Let us imagine a simple example. Here is a print, representing a field with standing shocks of corn; containing a very intelligible record of the scene. But how far is it a picture? Our estimate will depend upon two considerations: the mere pattern of black and white upon the paper and the amount of its suggestion. Is the pattern

in its abstract representation of forms and spaces well-balanced, intrinsically handsome? Has it admirable qualities of color; richness in the blacks, clarity in the lightest parts, and fine gradations of intermediate tones; or, instead, has it a general delicacy of less contrasted tones; or, again has it the vivacity of a few tones, strongly contrasted? Moreover, is the lighter part really suggestive of light or merely a contrast to the darker parts, and are the receding planes of the picture, whether many or few, represented with the fluid continuity of the "values" in nature? Then, secondly, what does the scene convey to us? Merely an accurate suggestion that the corn has been cut and stacked in sheaves? or, are we made to feel that nature for the time being has done her labor; that the fulness of her strength has been expended, that she is resting like a strong man in the grand consciousness of work accomplished, her forces relaxed temporarily in the glow and luxury of well-earned ease?

In this ramble over the broad field of landscape, a few points stand out with particular distinctness. To make a beautiful picture of landscape, or to appreciate it, something more is needed than a taste for the picturesque: there must be a real love of nature, which leads to close study of it and a growing companionship with its moods and changes. Nature must mean something to our inner-most life. When the artist has entered into nature and allowed it to enter into him, his work, however simple, becomes impregnated with a sincerity that is unmistakable to any careful observer, just as the half-hearted motive of him who is merely trying to take pretty pictures can be at once detected. It is this sincerity that leads the artist to eschew the trivial and seek for the large qualities in a

landscape; to feel so deeply the meaning of these that he can communicate the feeling to us and, so, recreate the emotion we might have received if ourselves in the presence of the scene. For the lover of nature can never be satisfied with a mere record of the physical facts; to him there is, as it were, a soul within them, and he looks in pictures for its interpretation. It would not be far wrong to say that landscape art is the real religious art of the present age.

CHAPTER VII.

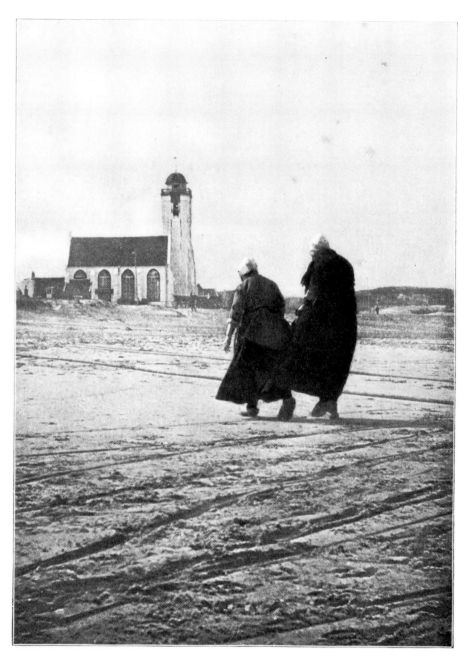

"SCURRYING HOME" *By Alfred Stieglitz*

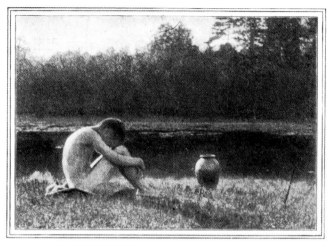

"THE URN" *By r'. H. Day*

CHAPTER VII

The Figure Subject in Pictorial Photography

N an article on "Figure Photography" in *Camera Notes*, occurs the following passage: "Neither has there to be behind the kodak or camera any special kind of photographer; anyone who can work quickly and precisely and quietly can do good work of this kind." Surely this is a surprising statement in view of the difficulties of figure picture-making generally, and of some special ones which confront the photographer particularly. Indeed, it can only be explained by assuming that the writer is not referring to picture-making at all, but only to the record of figures by means of photography, as a pleasant pastime for the peripatetic snap-shooter. This conclusion seems warranted by the sentence which follows: "If any special qualification is required, it is the power of *seeing everything at once*, not such a difficult thing for those of

average eyesight as it may appear; though difficult, if not impossible, to those who are short-sighted or those who have to wear spectacles.'

The statement will give great encouragement and satisfaction to hundreds of photographers who are executing just the kind of work that might be expected to result from such limited qualifications, and who will have found confirmation of what no doubt they already feel, that their work is all which can be desired. A similar narrowness of aim distinguishes a great many painters' treatment of the figure, and this blindness to the higher possibilities of the figure subject is very generally shared by the public. It may not be amiss to try and enter into the purpose which actuates artists, whether painters or photographers, in approaching this most fascinating branch of art. And first let me attempt a general consideration of the matter; venturing afterwards to try and discover its special application to photography.

It was a pretty saying of Pope's that "the noblest study of mankind is man." The dictum is, perhaps, a little too pat to be precise, yet, on the whole has been justified by centuries of artistic tradition which puts the study of the human figure in the front rank of pictorial motive; and there is little doubt that to the public at large the figure subject has more attractions than any other. Let us note from what very different points of view the public and the best artists have reached this agreement.

To the former, the prime charm of a figure picture consists in its "human interest"; to the artist, in the possibilities of beauty inherent in the human figure. The two ideas may be summarized as, respectively, the illustrative

and the decorative; and both may be represented in the same picture, but never, if it is the work of a great artist, will the latter be missing. Stated otherwise, the difference is that between the mere record of facts and the way in which they are recorded. The average public looks only for the portrayal of some incident or story; eagerly inquires the title of the picture and "what it is all about"; searches the picture in order to satisfy itself that the facts have been literally rendered; demands a pictorial inventory of the circumstances and criticises them as to their accuracy and completeness. It looks for a detailed statement rendered after the manner of the literary man; ignoring the sep-

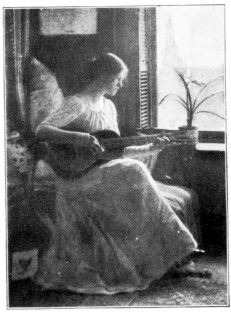

By J. A. Dimock, New York
"GIRL AND GUITAR"

arate, individual qualities and possibilities of a picture and considering it merely as an appendage to the pen; an illustration, in fact, in the boldest acceptation of the term.

This view of the figure picture is no new one; being prevalent enough in the days of the Italian Renaissance, during the earlier half of the fifteenth century, when the artist was engaged by priestly and lay patrons to paint religious subjects. How well Browning has summarized the motive and the effect when he makes Fra Lippo Lippi say:

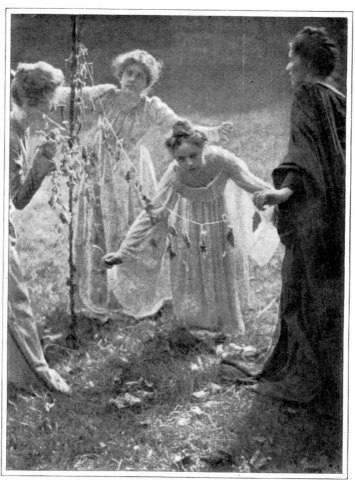

"THE MAY-POLE" *By Clarence H. White*

PHOTOGRAPHY AS A FINE ART

"I painted a Saint Laurence six months since
 At Prato, splashed the fresco in fine style:
'How looks my painting, now the scaffold's down?'
 I ask a brother: 'Hugely,' he returns—
'Already not one phiz of your three slaves
 Who turn the Deacon off his toasted side,
But's scratched and prodded to our heart's content.
 The pious people have so eased their own
With coming to say prayers there in a rage:
 We get on fast to see the bricks beneath.
Expect another job this time next year,
 For pity and religion grow i' the crowd—
Your painting serves its purpose!' Hang the fools!"

And "Hang the fools!" is still re-echoed by the
exasperated artist of today when he finds his point of view
so entirely misunderstood or ignored by the public; the
latter confining their intention to what he says in neglect
of his way of saying it. They miss the point that if
picture-making is a method of expression independent of
the literary method, it should be judged by those qualities
which are peculiar to itself. For, judged by the literary
standard, the painter or photographer is at a disadvantage
with the writer, since he cannot include in his picture
the sequence of circumstances and of emotions leading up
to the culminating point. But, on the other hand, in the
terseness of his presentment and the vividness with which
he can flash his meaning instantaneously upon our con-
sciousness, the advantage is all with him; and the extent
to which he relies upon these qualities, both in the choice
of subject and in manner of rendering it, will be his
measure of success.

For not every subject will serve his turn. There is a class of subject readily adapted to the leisurely, methodic, analytical process of the writer; and quite another kind appropriate to pictorial presentment which should be synthetic, no matter how analytical may have been the study which preceded it. And the subject as he presents it must be self-sufficient, needing no other justification for existence than its own beauty, force or character; and if it involves a story, self-explanatory, not dependent upon quotations of prose or verse to make the simple meaning of its title intelligible.

As regards the conception of the subject, we may gather from a study of great works, that the main points are that the subject has been thoroughly comprehended, sincerely felt, and pictured fully in the brain before its representation is commenced. This antecedent realization may be the result, either of profound study and experiment or of a momentary suggestion, vividly seized. The model, for example, may be resting. The limbs, freed from restraint, loosen into lines of unconscious *abandon*; at the same moment, perhaps, the sunlight falls upon the polished bosses of the shoulder and breast, while shadow wraps the remainder in a certain mystery. The artist sees at once the pictorial possibilities, he is filled with enthusiasm, seizes the charcoal or adjusts the camera and records his impressions red-hot. Later he may develop his study into a picture, trying to bring out those qualities which had impressed him so vividly, and last of all may put a name to the picture. But the title was not the genesis of the picture, which had its inspiration in the chance presentment of a subject of *abstract* beauty; and we shall not reach an appreciation of his work by poring over the title and

endeavoring to square the representation with it. Least of all shall we ever put ourselves in sympathy with the artist if we suppose that great work necessarily involves a great and elevated subject. The artists of the Venetian School were great men, who lived in big and stirring

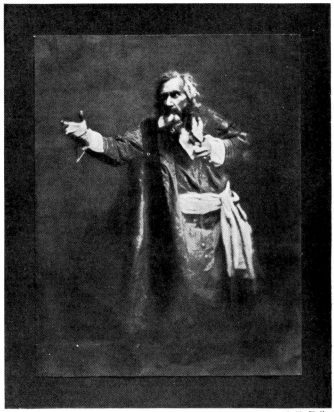

"SHYLOCK—A STUDY" *By Joseph T. Keiley*

times, intimate with women of noble build and with men distinguished by enterprise, ambition and intense pride of country, yet these artists often seem to have been striving most consciously to represent the gorgeous color and texture of rich fabrics and the fascination of light upon ripely

rounded limbs. That we find such pictures great is due to the large manner in which motives, comparatively trivial, have been expressed. And is not this a common experience of ourselves? When we were young, we had such big thoughts, as far beyond our capacity of expression as of our comprehension ; as we mature, our horizon narrows, but the sense of vision grows; we reach out and grasp, alas! very much smaller things, but with a livelier comprehension and an increase of ownership, that compensate for their limitations.

The conception of the subject, however, may be the product of long and careful study. Such is Millet's *Sower*. His sympathies were with the laborer; he knew him intimately in the going in and out of daily life ; the solitary figure passing rapidly down the furrow, scattering grain that in the fulness of the season was to mean life to himself and others, had been noted time and again with penetrating comprehensiveness, not only in its individual characteristics but in its relation to the big scheme of life. So that when at length the artist realized the fruits of study, he portrayed not *a* sower, but *The Sower*; a typal embodiment which by force of the knowledge and sincerity involved must remain a classic.

On the other hand there were recently exhibited some photographs of a Sicilian sower in various phases of his occupation. Why did they fail, as I think they did, of satisfactory rendering ? Because they were simply illustrations of arrested movement, revealing no study of the salient characteristics of the subject or any attempt to unite them in one epitome. In this way the motive had not been sincere. The photographer may have had Millet's picture in his mind and, certainly, had been attracted by

the peasant's costume and how it would lend itself to a picture out of the ordinary. He came and saw and snapped his camera, but did not conquer the intimate inner qualities of the subject. His prints were merely snap-shots, and if he had taken a number of different attitudes and then combined them in one of those rotary contrivances that mingle the separate units into an organic movement, the latter might have come

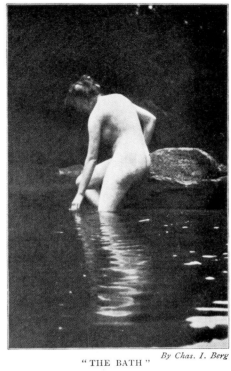

"THE BATH" *By Chas. I. Berg*

somewhere near to being an equivalent of Millet's picture. But, as it was, these prints were a fair example of what must have been in the mind of the writer in *Camera Notes,* quoted above : "Anyone who can work quickly and precisely and quietly, can do good work of this kind"; merely interesting records of a tour in search of the picturesque.

Oh! that same word "picturesque"—what a fogginess of misconception it involves ! Pictorial is intelligible ; it is the picture equivalent for actual facts, but the suffix "esque" puts the idea into the category of "kind o'"; not pictorial, but "kind o' so." It represents that quality of mind which cannot find pictorial motive in a building unless decay has settled down upon it, in a human being

unless clothed in some unfamiliar costume. There are painters, as well as photographers who compass lands and seas to find lawn caps, stiff bodices and cheap jewelry, because, as they say, such lend themselves to picturesqueness, as if the country life at home were barren of pictorial suggestion. Surely, the barrenness is in their own imaginations. It is a notable fact that when Israels and Blommers or other Dutch painters portray a peasant of Holland you are hardly reminded of the costume, whereas when the American or Englishman essays the same theme, you are conscious of little else. The former are not attracted primarily by the little local accidents, but by the large universal truths of human nature, which are equally to be found at home by him who has sympathetic discernment and a true eye for seeing. Indeed, among painters and photographers alike, there seem to be two orders of mind or habits of seeing; one continually searching for the picturesque, the other seeing everything pictorially. The former are by comparison journeymen hunting for soft jobs, the others artists, with the constructive, creative gift, who can take a fact, however old or hackneyed, and reshape it into something vitally fresh, because they infuse into it something of their own personality.

While the picture-maker proves himself to be an artist by the selection of a subject particularly adapted to pictorial representation, by the thoroughness with which he grasps its salient characteristics, and by the vividness of his antecedent conception, he does so also by the reliance which he places on the methods of expression peculiar to his art. How few people realize that these are abstract and make their primary appeal to the eye! Later, in the case of certain subjects, they may reach the intellect, but even

"MOTHER AND CHILD"

then through the passage-way of the senses. In literature, on the contrary, the words travel direct to the intellect and may later arouse a brain impression as of a picture seen. But in the actual picture of painting or photography, it is the things seen which affect us. and the

"THE LETTER BOX" *By Alfred Stieglitz*

artist's skill is shown in what he offers to our sight and ours in the receptivity of our vision. He offers us certainly a concrete fact—some figure or incident; he cannot help himself, and this is his limitation, as compared with the musician who transports us at once into the abstract. His feet are necessarily of clay, and for the

most part the public never look above his knees, and so fail to discover that in the development of the concrete he has reached up into the abstract. The lines of his picture, the shape of the forms and their union into one composition are designed to yield pleasure to our eyes; so also the colors, individually and in their harmony of relation, will play upon the eye, as music on the ear, arousing actual emotions of depth or delicacy, as the case may be, which the distribution of light and dark throughout the picture will increase, while the representation of texture on the surfaces of the different objects, tickling by suggestion the sense of touch, will add a further source of pleasure. The picture that does not represent the subject with some, at least, of these qualities is as barren of enjoyment to a cultivated taste as the property pie which does service for real pie in a stage play; and the person who cannot realize enjoyment from these qualities is like a man eating strawberries after he has lost his senses of taste and smell.

In confirmation of this point, that the essential beauty of a picture consists in these abstract qualities, let us recall a few that are accepted masterpieces; for example, (I select at random) Titian's *Assumption*, Rubens's *Descent from the Cross*, Raphael's *Madonnas*, and, to come nearer home, John La Farge's *Ascension*, in the Church of the Ascension, New York. Is it the subject in each case that is responsible for the impressiveness? Scarcely, for we have seen representations of the same subject that have left us cold. Rather, it is an eloquence resulting from the pictorial qualities: in the *Assumption*, a superb massing of stately form and glorious color and the suggestion of uplifting movement; in the *Descent from the Cross*, the impressive contrast of light and dark, the white, drooping

form of the Savior so pathetically relieved against the solemn gravity of the dark figures massed around it. Raphael sheds over his Madonnas a golden haze of tenderness, that translates a simple peasant girl into a typal expression of maternal and divine love; and John La Farge, partly by the noble adjustment of the figures to the spaces and partly by the ringing dignity of the color scheme draws our imagination upward with the ascending figure. These are not exhaustive statements of the sources of gratification in these pictures or of the means employed to bring the story or meaning home to us, but enough, perhaps, to suggest that the latter are purely abstract, and that through reliance upon these abstract qualities the sublimity, pathos or tenderness of the subject has been developed. In all these pictures the illustrative and the decorative motives, to which allusion was made above, are combined; and, if the abstract qualities are so important in their case, it will be admitted that they must be more so when the motive is singly decorative. In this case, indeed, a complete reliance upon them can be the only justification for adopting it.

So far we have been discussing the general principles involved in the making of figure-pictures, and may now apply them more particularly to photography. Surely they demand, except in the case of purely illustrative prints, such as are used in the daily and weekly papers, qualifications which by no means every one possesses; calling, in fact, for qualities of a very high artistic order. It cannot be too often insisted that the mere snap-shooting of figures or the mere posing of them in some agreeable position is as far removed from the artistic possibilities of picture photography as night from day. The ultimate

"TESTING FRUIT" By H. A. Latimer, Boston

possibilities of the art are only matter of conjecture, but already results are obtained which would have been deemed impossible a short time ago, and their beauty proceeds from reliance upon the artistic qualities common to painting, with the sole exception of many colors. The photograph is still a monochrome; yet in the opportunities it gives of rich and delicate tones, the limitation is less of a hindrance than some would suppose. The real limitation, the one most difficult to circumvent, comes from the physical and mental imperfections of the model. In studies from the nude this fact is often painfully apparent. Even when the form is comparatively free from faults, a consciousness or even an excess of unconsciousness, amounting to blank indifference, or some simpering expression of sentiment will mar the picture. And yet we have seen how successfully this difficulty has been surmounted by Frank Eugene and F. Holland Day. The latter has done some very beautiful work from the nude model, particularly with a Nubian, and again with children. His motive in these, I should imagine, has been purely decorative; and it is the entire absence of any sentiment that is an element in his success, since it leaves one to uninterrupted enjoyment of the beauties of form, color and texture. Mr. Eugene, also, in his *Adam and Eve* has obliterated the faces by scoring the surface of the plate with lines. The reason is obvious, and again we find ourselves concentrated upon the abstract beauties of the picture. These and other examples, in fact, suggest a conclusion that the best way of securing an acceptable picture in the nude is by adopting some expedient to cancel the personality of the model, either by hiding the face, or by keeping the figure far back in the picture whence the

features do not count, or else by so accentuating the other elements of the picture that the attention is diverted from the face.

In the *genre* picture also this problem has to be met in a mitigated form, for the least self-consciousness stiffens, and under- or over-realization of the part that is being played may jar upon the general feeling of the subject. But in *genre* the accessories may be made to play, and ought to play, so important a part that the figure becomes merged in them, if properly treated. Indeed, one may almost divide the examples of this class of picture into two kinds: those in which there is a *mise-en-scene* including figures and those in which there are figures with some sort of

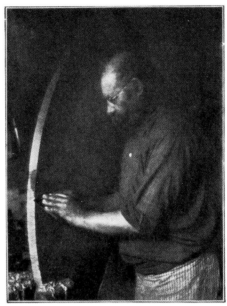

By Miss F. B. Johnston, Washington
"A ROYCROFTER"

setting added, and it is the former which, in photography at least, appear to be the more satisfactory ; and such complete identity of figure and environment demands the most synthetic arrangement. If a profusion of detail is allowed, the figure will necessarily obtrude itself, without, however, necessarily gaining separate importance, for the general confusion distracts. While, therefore, there should be some central motive to which everything is subordinated, the same should not be the figures, but some abstract

quality, especially that of the lighting of the picture. Let this clearly express the sentiment of the picture, as it may very readily be made to do, and everything will fall into due relation to it, the accessories as well as the figure, and the latter, relieved from the chief burden of expressing the meaning of the picture, will contribute its share with all the greater spontaneity.

On the other hand, the artist may wish to solve the problem by confronting it instead of getting around it, and may determine to make the expression of the face the prime factor in the picture. Then he must either find a model that already corresponds to his conception, that may, indeed, have inspired it, or he will diligently coach his model, or, as a final resort, act as model himself. Here, again, I am reminded of Mr. Day, who in several cases, notably in a series of heads, portraying the *Seven Last Words* of the Savior, posed for himself. Silly objections have been raised to this on the score of propriety, as if all the religious pictures had not been painted from models. A more tenable criticism would be that the theme is too tremendous to be treated with main reliance on the expression of the faces as in this case, and that the result attained, though very impressive, is rather histrionic than religious.

This allusion to religious subjects reminds one of many points depicting some tragic emotion, none of which seemed satisfactory. I recall, especially, some examples by Mr. Clarence H. White, cleverly posed and very beautiful in their rich quality of color. Their failure to convey the impression intended may possibly be due to the fact that Mr. White's temperament does not so strongly incline towards such subjects as to others of tenderer senti-

ment. At least such might be inferred from a study of a large number of his prints. Mr. Joseph A. Keiley has also essayed this kind of picture, as in the case of a Shylock, using an actor for a model and relying very much upon the latter's contribution to the result. But an actor's power to create an impression is in a general way a relative one; dependent to a great extent upon the readiness of his audience to accept the illusion. Between the two there is a constant reciprocity of feeling and the connecting link is the sequence of the words. In a picture the artist has to establish the connection in order to help out the efforts of his model, and it is just because Mr. Keiley has depended too exclusively on the cleverness of his model, that he seems to me to have failed. And this brings one back to the point, which the more one thinks of it seems of greater importance, that to succeed in *genre* the artist must make some abstract quality the prime feature of his picture.

So far I have been considering the deliberate posing of the model; but there is a class of pictures in which the figure is introduced without its knowledge or, at any rate, without knowledge of the actual moment at which the exposure is made. Mr. Alfred Stieglitz has done some notable work in this direction, particularly in the series of pictures, made at Katwyk, and they bear out what I have said about the wisdom of subordinating the figure to some abstract motive. In *The Gossips*, for example, and *Going to Church*, he has treated the figures as part of the scene, related to it and deriving from it their own significance. And the pictures were not made, I understand, until the essential features of the subject had been thoroughly digested and the relation of the figures to the scene and

the exact part they should play in it, as to position and relative importance from a pictorial standpoint, had been well considered. This brings one back to the comparison of Millet's *Sower* with the photographs of a Sicilian sower. Can the photographer emulate the methods of the painter, even if he fail to reach his results? I am unable to see why not. Millet must have made an exhaustive analysis of the man at work until he had mastered the salient features of the operation; then, many studies were probably executed before he reached the final formula of expression. The analysis is certainly within the possibilities of the photographer; and repeated snap-shots might take the place of sketches, until, at last, the desired result has been attained. But this involves the sincerity, patience and self-criticism that mark the procedure of the artist, very far removed from the easy conscience and ready self-satisfaction of a mere toucher of the button. It distinguishes the artist of the camera from him who is only playing with it, and justifies the statement that really good figure-photography, so far from being a thing in which any one can sncceed, is indeed the highest test of the photographer's ability.

This problem of expressing movement seems full of difficulty. Some years ago a number of photographs were publicly exhibited, representing the position of horses at different instants of their gait, and it was clear, at once, that such positions were entirely different from those depicted by painters and accepted by the public as true to life. Immediately it was assumed that, as the painter was manifestly untrue to life, he must be wrong; the point being missed, that according to our sense of what we see, the photographs themselves were entirely false. The picture-maker does not attempt to depict the actual thing,

but the impression which it makes upon him, and, in the matter of a horse's gallop, sums up the different phases of the gait into one synthetic formula; which may be arbitrary, but justified, if it succeeds in conveying the impression to ourselves. Therefore, the snap-shot, while no doubt recording accurately some instant of the action, may be very far from expressing the composite result, conveying instead a suggestion of suspended movement. For one photograph of a man walking, a hundred can be seen in which he appears to be standing on one leg with the other held up in the air as if it had been hurt.

But the difficulties which photography presents are the measure of its possibilities. If anyone could succeed there would be no chance for the artist. It is in a realization of the difficulties and in the persistent endeavor to surmount them that picture photography is being gradually brought to the level of an art.